Historic Tales
from
AHWATUKEE
FOOTHILLS

Historic Tales
from
AHWATUKEE
FOOTHILLS

MARTIN W. GIBSON

INTRODUCTION BY A. WAYNE SMITH

THE
History
PRESS

Published by The History Press
Charleston, SC
www.historypress.com

First published 2019

Manufactured in the United States

ISBN 9781467140317

Library of Congress Control Number: 2018959006

*To my brother and sisters—Jim, Mary, Pat, Marge and Chris—with whom
I've shared the journey thus far and hope to continue journeying
through volume ten of this series.*

CONTENTS

CONTENTS

INTRODUCTION

Riding my horse over the Warner Road freeway overpass, with the desert at the foot of South Mountain laid out before me, not for a moment did I imagine that this would be home to almost ninety thousand people some fifty years later. Never did I dream that I would have had a hand in helping to transform this open desert into what it has become today.

Arriving in the Valley of the Sun from Missouri in the mid-1960s, I had advanced degrees in urban planning and landscape architecture but little experience in either. A year and a half working for the Maricopa County Planning Department led me to start my own land-planning firm in a tiny office on Tempe's Rural Road.

So it was that when my neighbor and local real estate broker Dick Zigman introduced me to California developer Randall Presley in early 1971, the field of landscape architecture was in its infancy. Presley had recently acquired more than two thousand acres across the freeway and, having built many thousands of homes in Orange County, California, had a few modest projects in progress on the west side of Phoenix. The California builder wanted to develop a retirement community here.

Arizona had very few planned communities in the early 1970s. Of the four roads crossing the freeway (Elliot, Warner, Ray and Williams Field, now Chandler Boulevard), only the latter had access ramps. When Mr. Presley arrived at my tiny Rural Road office in a stretch limousine, the driver was unable to turn the car around in our office's small parking lot. But that initial

meeting brought a synergy in our thinking, with the California developer laying out his vision for a retirement community across the freeway in the foothills of South Mountain.

Developer Ross Cortese, like Presley a major Orange County builder, had begun developing the retirement community of Leisure World in east Mesa. A large ornamental globe at the project's entrance greeted residents and visitors alike and became something of a southeast Valley landmark. Similarly, Randall Presley envisioned a grand entrance to his planned community, something to rival Cortese's signature Mesa globe. He described his vision of a lavishly landscaped traffic circle as one entered the retirement community on Elliot Road, one that would herald the arrival at what was to become Ahwatukee. But Orange County's grandeur stood in stark contrast to the more austere Maricopa County, and Presley's grand entrance was never built.

Discussions with Presley led to his initial concept of a retirement community being expanded to also include adult and family living in a mixed-use community, with an arterial loop keeping heavy traffic off residential roadways. In the spring of 1971 we began work on the Tempe property (as the land west of Interstate 10 was referred to then) Master Development Plan. There were few photos included in the plan because there was nothing there! Nothing but raw desert…and terrific views of South Mountain.

Neither Tempe nor Chandler was interested in taking on the cost and obligations associated with bringing water or utilities to an area that at the time was considered to be isolated, remote and unpromising. But Presley found a willing partner in the City of Phoenix, and Phase I of the master plan was approved in November 1971.

Planned-community design involves a process known as constraint studies, which examine the ramifications of utilities, traffic, soil types, drainage and flood potential. Hydrology studies demonstrated the need for elaborate drainage provisions due to the land's proximity to South Mountain. Eighteen acres originally designated for drainage were expanded to more than one hundred, leading to the construction several years later of a second golf course through which large amounts of water runoff could flow on their way to a large retention basin on the east side of Interstate 10.

During the early years of the project, there was lots of open desert to absorb the extreme volume of water coming off the mountain. As more houses were built and less open desert was available, the runoff had to be channeled through those one hundred acres. Golf course designer Gary Panks created an innovative solution by designing four tiered lakes, with the

one closest to the mountain slowing water flow before feeding it into each of the next three lakes, with each lake further slowing the flow. Thus The Lakes Golf Course was designed as much for drainage management as for golf.

During the course of our Ahwatukee work I was introduced to Leroy Smith, a land investor and owner of Pima Ranch, a 2,670-acre property directly south of Presley's. To increase the marketability of his property, Smith asked in 1977 that we create a preliminary development plan for what would eventually become Mountain Park Ranch.

A former client and president of American Continental Corporation, Charles Keating, expressed interest in the property. While he, a few Continental executives and I toured Pima Ranch on a hot July day, the car in which we were riding became stuck in a gully at the site of today's Mountain Parkway—then little more than a dusty foothill ravine. In the pre-cellphone era, Keating and company remained in the vehicle with all four wheels off the ground while I ran several miles back to Chandler Boulevard and over the freeway to summon help via the nearest phone. As both tour guide and guardian angel, I figured that it was all just part of the job.

Preserving the uniqueness of Pima Ranch's foothills was one of our goals and that of Continental Homes' joint-venture partner, Genstar, which took over under the leadership of project manager Ron Lane. The sweeping vistas and open spaces one sees today reflect Lane's dedication to working with the land as it was and not trying to fit it into some pre-conceived notion of what it should be.

In retrospect, my one disappointment in both Ahwatukee and Mountain Park Ranch lies with the City of Phoenix. Relaxed zoning codes allowed the employment buffer originally planned for the area between South 48th Street and I-10 to evolve from orderly commercial and employment centers offering the possibility of living and working in proximity to high-density residential housing. The commuter culture and traffic flow have been adversely affected—a major quality of life issue.

To the west, International Harvester's prior excavation and testing of large earthmoving equipment on its Phoenix Proving Grounds defined the eventual Foothills property purchased by Burns International. The developer worked with Harvester's existing test-track roadways in both high-density traffic areas as well as within subdivisions, so as not to further scar the land. With the City of Phoenix providing utility services, our firm was brought in early on when it became apparent that, absent a Master Development Plan, planning oversight and guidance were needed. In the Foothills we helped to identify large parcels of land on which individual builders could plan their

own subdivisions, which greatly simplified the development process.

The experience gained from these early master-planned communities helped tremendously in other developments in which we were involved, such as McCormick Ranch, Gainey Ranch, Scottsdale Ranch, Chandler's Ocotillo and Rio Verde. In addition, the many projects overseen in our Albuquerque, New Mexico and Las Vegas offices all benefited from the knowledge and experience gained in the earliest days of the eventual Ahwatukee-Foothills. As much as anything, our desire was always to create communities that hold their value and maintain a desirable living experience.

Happily, some of the more intriguing players, events and landmarks from times long past have been captured in this book by Marty Gibson. Taken together, they help to preserve the history of the village. It all seems so obvious now, but in the early 1970s it was impossible to imagine the growth that was about to transform the East Valley. I feel privileged to have had a hand in helping to shape the area's development—and no longer ride my horse over the freeway. Horses and cars don't blend well together. But while my view from the Warner Road overpass has certainly changed, in a fundamental way it will always remain the same.

A. WAYNE SMITH
December 2018

Acknowledgements

O nly through the graciousness of many individuals is a book like this possible, and I am privileged to have been the recipient of countless acts of boundless generosity.

Individuals and institutions to whom I am indebted include ACS's Margerie Green, ADOT's Doug Nintzel, Landiscor's Nora Hannah and Jennifer Kellerman, Taliesin West's Margo Stipe and Bruce Pfeiffer, the Wisconsin Historical Society's Lee Grady and the *Ahwatukee Foothills News*' Paul Maryniak.

Three individuals in particular deserve singular thanks. I am honored that A. Wayne Smith has lent his recollections, experience and perspective to this book. It is that much the richer for it. Gay Farley Leon distinguished herself with editorial skills and insights that were essential in helping achieve a better finished product. Consistently gracious about lending her discerning eye to my written word, Gay's meticulousness has served me—and, I trust, the reader—well. And for her enduring support, Mary West has earned my particular appreciation.

Deserving of special thanks are those who invited me into their living rooms, kitchens, dens and offices as they shared their recollections of days past. Posthumously, Patty Artist, Tom Carney, John Driggs, Helen and Richard Evans, Eli Gates, Lois Garner, Joe LeChaix, Tom and Jack Owens, Randall Presley, Reverend Don Schneider, Marion Vance and Buck Weber are all fondly remembered. And I will be forever indebted to Jan Baratta, Art Brooks, Elaine and Jim Burgess, Carolina Butler, Chad Chadderton,

Sal DiCiccio, Rick Evans, Ben Furlong, Joe Garner, Bruce Gillam, Jack Gleason, Ruth and Jim Goldman, Tom Kirk, Ron Lane, Susan Livingston, Kathy Martin, Pete Meier, Linda and Tom Olson, Judy and John Ratliff, Mark Salem, Rick Savagian, Clay Schad, Charles Schiffner, Vern Swaback, Jim Spadafore, Tom and Mike Vance, Bernie and Marty Weber and Lew Wilmot. Not all of their stories were suitable for print, but their knowledge and insight helped keep me going.

Lastly, some of these narratives began as short columns published in the *Ahwatukee Foothills News* or local magazines. Those that did have since been expanded, enhanced and, in the process, made much more complete, informative and, hopefully, interesting. You be the judge.

SCHOOL'S IN

*I*n the days before there were twenty-five elementary and middle schools in the Kyrene School district, everyone in the community went to the same school. Children of the few farmers in the eventual Ahwatukee Foothills all attended grades one through eight at what was the only school in town: the Kyrene School, on the northwest corner of Kyrene and Warner Roads. Right up until development of the original Ahwatukee began in the early 1970s, the area we call home was part of the Kyrene farming community, its mailing address all postal route box numbers. "Tempe" was the destination on the envelope.

Bordered on the east by the eventual Price Road, on the south by the Gila River Indian Community, on the west by South Mountain and on the north by Guadalupe Road, the Kyrene School District was created in 1888 in Colonel James McClintock's one-room wooden schoolhouse at the corner of what would become Warner Road and McClintock Drive. The building promptly blew down in a windstorm and was replaced with a stronger one-room schoolhouse. But in 1920, waterlogged school grounds caused by an unusually high water table as a result of continual farm irrigation dictated that the Kyrene School be moved to Warner and Kyrene Roads. To help alleviate the problem, in the late 1920s Salt River Project constructed a twenty-five-foot-deep drainage ditch along Rural Road—for decades called Canal Road—that drained all the way to the Gila River. Today the drainage channel runs underground.

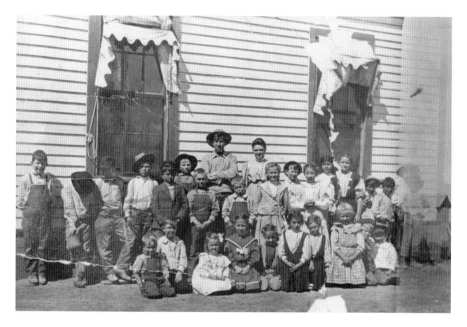

The 1908 student body of the Kyrene School, grades one through eight, on the site of the district's second one-room schoolhouse. *Courtesy Kyrene School District.*

Four small adobe cottages (housing two grades apiece) were constructed in 1920 on ten acres at the present site of the Kyrene School District administration building. Prominent pre–Ahwatukee Foothills names like Warner, Hunter, Williams, Collier, Evans and Gates dotted the rosters of early Kyrene governing boards and Parent Teacher Associations.

Longtime area resident Tom Owens (Kyrene School class of '31) recalled an area so rural in the decades before World War II that barely a half dozen farm families and perhaps ten children lived within a mile radius of the school. The entire Kyrene student body of grades one through eight totaled sixty when Owens attended. "Back then, three cars going by Kyrene School was a traffic jam," joked the former Kyrene farmer. "When I was a little kid my Dad bought me a pony named Dolly. She was a little too much for me to handle so he sold her to Mr. [Byron] Slawson. He had a little cart made of half a barrel and a couple of wheels, and Dolly would ride all of their kids down to Kyrene School in that cart every day. There was a square cement trough, and they'd tie the horse along the fence, leave her there all day long and water her there at school. Then, after the kids got out of school, they'd ride down Warner Road back home." It was not until 1970 that a second school,

Waggoner, was added to the district, to be followed six years later by the first school in the fledgling Ahwatukee: Kyrene de las Lomas, on the newly completed Warner-Elliot Loop.

Unencumbered by iPods, cellphones or text messages, students' days typically began with chores on the farm. Tom Carney, a classmate of Owens in the class of '31, arose at 3:00 a.m. to milk cows and do other chores before heading off to school—a common routine for most schoolkids in the Kyrene farming community. Rising early was a way of life on the farm. In the days before conditioned air Carney, the oldest of six, slept outdoors on the family's front porch along with his brothers and parents. The three boys' beds were at one end of the porch and his parents' at the other, with Tom's three sisters fast asleep in the living room. In those days, several of his classmates' formal education ended when they returned to the farm after eighth grade. Most students either walked or rode horses to school, tethering them to that fence during the school day. Four wheels signaled the eventual replacement of four legs in 1926, with the arrival of a singular Model T school bus that serviced the entire district. Its seats were a few wooden boards and its driver one of the school's teachers.

As in most farming communities, church and school played integral roles in Kyrene students' lives. The area's 4-H Club and the Boy and

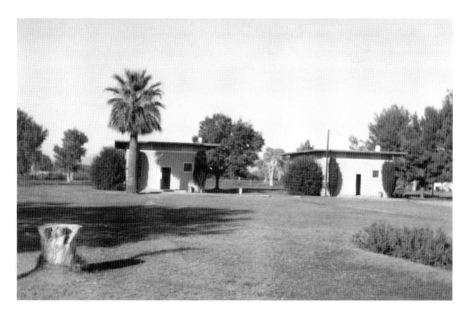

Two of the four buildings on the ten-acre campus at Warner and Kyrene Roads. *Courtesy Kyrene School District.*

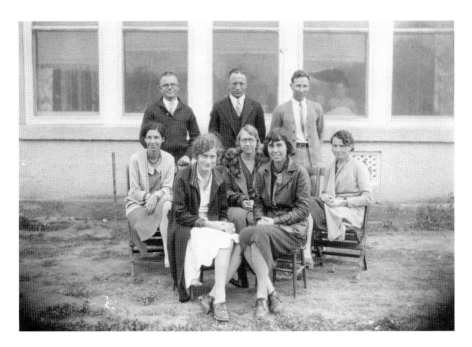

The Kyrene faculty in 1935. At least one of these teachers doubled as the district's school bus driver. *Courtesy Kyrene School District.*

Girl Scouts met on school grounds. With no house of worship, Kyrene School's auditorium served as the primary place of religious gatherings and Sunday school. The end of the school year was a family affair, with a family picnic and father-and-son softball games in the schoolyard closing out the memorable last day.

Beginning in the 1950s the Kyrene School presented celebratory pageants, some at the end of a remote and seldom-used dirt road that meandered west toward the foot of South Mountain. Elliott Road's Old West, pre-loop setting is illustrative of the simplicity of life in the Kyrene farming community. According to Ben Furlong, whose definitive "The Story of Kyrene" charted the history of the Kyrene School District, "In 1963 a Christmas pageant was held during the day at the base of the South Mountains in an amphitheater near the west end of Elliot Road. It was a major undertaking to move all of the equipment to the site….Joseph's donkey got loose and went up the side of the mountain," disrupting the pageant until several students and teachers could persuade the stubborn beast to rejoin the play. For children at the Kyrene School, it was just another day at the office.

As development arrived and the Kyrene School District expanded, more schools were built to bring the total of elementary and middle schools to its present twenty-five. In today's wireless world, it's nearly impossible for students to relate to some of the hardships that their predecessors seamlessly faced. For those self-reliant children of the area's hardy early farmers, there were all kinds of ways to get an education.

ON THE STREET WHERE HE LIVED

Laboring on the docks of Long Beach, California, shortly after the turn of the twentieth century, Arthur Hunter loaded and unloaded lumber from ships. It was backbreaking work, held little prospect for advancement and was certainly no way to impress a prospective father-in-law.

That became an issue when Arthur took a liking to Mollie, youngest child of Jacob Williams, a wealthy Long Beach landowner. Marriage was out of the question unless Hunter could provide for Mollie in a manner unattainable on the docks. Reading about land for the taking in the Arizona Territory, the twenty-one-year-old Arthur headed east to the future Ahwatukee Foothills in 1909. Hunter longed for land that he could call his own regardless of his marriage prospects.

Under the federal government's Homestead Act, settlers could claim 160-acre quarter-sections of land, provided that they lived on the land and made certain improvements to it, typically by cultivating some of the acreage. How he came to choose his homesite is lost to history, but Arthur Hunter settled on the east side of today's South 48th Street just south of its intersection with present-day Thistle Landing. As the first settler on the narrow dirt road, it soon began appearing on maps as Hunter Drive.

To clear the land Hunter used an old railroad tie and some discarded spikes to create a comb-like device that was pulled by a mule. Painstakingly, fertile farmland slowly grew out of barren desert. That the newly built Highline Canal crossed under a small wooden bridge on Hunter Drive and

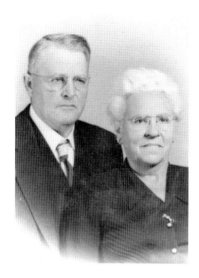

Arthur and Mollie Hunter, circa 1960s, married in 1911 and lived on the country lane that bore their surname. *Courtesy Lois and Joseph Garner.*

provided a ready source of irrigation for his crops showed that Hunter had done his homework.

Marrying Mollie in 1911, he built a house in which the couple would raise eight children and continue to live for the next sixty-three years. In addition to Arizona's statehood, 1912 marked the year when determined father-in-law Jacob Williams traveled by wagon from Long Beach to the Hunter homestead to check up on the newlyweds and personally certify that his son-in-law was indeed a worthy husband. Williams brought citrus seeds that Hunter planted around his farmhouse, and during his visit Hunter's father-in-law acquired several parcels of land south of Hunter's homestead, including the site where Pecos Park now sits. To hedge his bet, Mollie's father set aside 160 acres just in case Hunter's attempt at homesteading didn't pan out.

Born in 1888, Hunter was a pioneer in the Salt River Valley Water Users Association and on the Kyrene School Board. Self-educated and a voracious reader who slept only one hour a night until the age of seventy-five—at which time he pronounced himself "tired" and doubled his amount of slumber to two hours—Arthur enrolled in every agricultural correspondence course he could find and became an expert in animal husbandry, crop rotation and water conservation. With twenty-five thousand chickens and a few hundred cows, Hunter sold milk and eggs and grew alfalfa in his fields. He leased state land for grazing all the way to the base of South Mountain. Now we call part of this land Mountain Park Ranch. And until Ahwatukee development began in 1973, mail was delivered to his Hunter Drive address of Route 2, Box 405, Tempe, Arizona.

Yesterday as today, freeways were controversial. During construction of the Maricopa Freeway (I-10) in the mid-1960s, Mollie Hunter's 1958 Ford Fairlane—which she never shifted into a higher gear than second—blew right through a makeshift stop sign erected in deference to huge earthmoving equipment grading the freeway-to-be. With siren blaring and lights flashing, a sheriff's deputy promptly gave chase. Grandson Joe Garner, from the

car's back seat, pleaded, "Grandma, you better pull over" as Mollie kept on driving, oblivious to the fact that she might have done something wrong. Not used to traffic-control devices—or traffic, for that matter—from her fifty-plus years residing on Hunter Drive, Mollie protested that it couldn't have been her when she finally stopped to talk to the deputy. When they got home, Arthur was furious and promptly paid a visit to the deputy. Despite Hunter's imposing presence (at six-foot-two, he had a massive, size-sixty-five-jacket upper body, piercing blue eyes and a voice one could hear across a forty-acre field), he failed to convince law enforcement that Mrs. Hunter was never to be stopped again.

When development of Ahwatukee began in the early 1970s, the City of Phoenix ran a water pipeline along Hunter Drive from the Weber wells south of the homestead (see page 58) to the water reservoir and lift station built in 1973 on the northwest corner of the intersection with Ray Road. Then, the sleepy, single-lane farm road that had borne the family's name for more than sixty years was rechristened South 48th Street. That marked one of many development-related firsts that year and signaled the area's transformation from that of hardy, self-sufficient and independent pioneers to one involving a bit less of those qualities in the future.

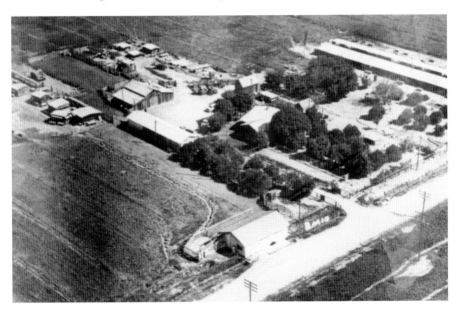

Settled in 1909, the Hunter homestead, seen here in the early 1950s, sits on the east side of Hunter Drive. *Courtesy Lois and Joseph Garner.*

The fierce self-reliance that enabled Arthur Hunter to carve out a hardscrabble living and provide for his family served him well over the years. Grandson Garner recalled a hot afternoon in 1963 when he and his grandfather were resting in the shade of a Chinaberry tree on Hunter's property. A man drove up and announced, "I'm looking for Mr. Hunter." Once properly introduced, the interloper explained, "I'm here to make you an offer on your land." Hunter replied firmly but matter-of-factly, "I'm not selling." When the would-be buyer wouldn't take no for an answer despite Hunter's repeated advisory that his land wasn't for sale at any price, the man said, "It's gonna be sold. So you might as well sell it to me." At that point, Hunter spoke firmly and matter-of-factly again, saying, "I detest rudeness," while calmly asking Garner to fetch him his 30/30 rifle from inside the house. To the man's skeptical inquiry of, "What's he gonna do, shoot me!?," Garner's firm but matter-of-fact reply was, "If you're still here when I get back with the gun—then yes." As soon as the individual caught a glimpse of Garner carrying the firearm, he didn't stick around to find out. Hunter's land remained in the family until 1997.

Arthur Hunter's 1974 death at age eighty-six left us with a mystery. Somewhere not too far from today's South 48th Street, between Thistle Landing and Ray Road, are pieces of a bullet-riddled 1916 Studebaker purchased by Hunter from Chicago mobster and periodic snowbird Al Capone in the late 1920s. After driving the car for a decade, Hunter cut it up into pieces and buried them in the barren desert. Of all the imponderables involving all the figures in history, were it possible to ask them just one question, few would seem to be of a more burning urgency than the one that we long to ask Arthur Hunter: "Why?"

WELCOME TO, AND IN, AHWATUKEE

*I*n the beginning, folks made fun of the name Ahwatukee. "Foothills" wasn't yet a part of the landscape, and neither was much else. The first homeowners moved into the original Ahwatukee in the fall of 1973, and by the following summer the community consisted of about two hundred houses, the country club golf course, the retirement recreation center and a walled compound for construction equipment—and that was it. Streetlights and fire hydrants were still to come.

Into this environment Reverend Ken Johnson; his wife, Arlene; and their three children moved from Portland, Oregon. Johnson was leading a parish there when the Lutheran Church in America identified a few Southwest communities having the potential for growth. The national church offered him the choice of starting a parish from the ground up in either established Scottsdale or in fledgling Ahwatukee. Anticipating faster growth in the latter, Johnson relocated his family in August 1974.

Those were lonely days for Johnson's oldest daughter, Pam, who was one of only a handful of high school students living in Ahwatukee. At Tempe High School, Pam's new community name drew laughs from her classmates, most of whom had never heard the A-word and had difficulty pronouncing it. With no churches in the vicinity, Pam's father recruited potential parishioners by going door to door—which, given the number of homes, didn't take all that long.

One of Johnson's first challenges was finding a suitable meeting place. The Ahwatukee Recreation Center's fifty-five-and-older age restriction precluded

younger families from meeting there, and there was little potential for a meeting place between Interstate 10 and Rural Road. Johnson persuaded the Kyrene School at Kyrene and Warner Roads to allow his tiny parish to meet in its multipurpose cafeteria.

The absence of air conditioning and a paved road from Ahwatukee made things interesting during monsoon season, but the school did have a piano. Unfortunately, hundreds of sheep leisurely straying onto or crossing Warner Road—a common occurrence during winter grazing season—caused the church's piano player to miss services completely on at least one occasion. Surrounded by feeder lots and a chicken ranch, the aroma was far from heavenly when the wind blew.

The startup parish's first worship service took place in the Johnson living room on South Ki Road in late November 1974. By year's end the congregation had grown to sixty-five parishioners. The church would hold services in the school's cafeteria for the next three years. Following a 7:00 p.m. Kyrene service that first Christmas Eve, a second one was held at 11:00 p.m. in an early Ahwatukee family's home. Barren of any furniture save for twenty-six folding chairs, the Mancardi family's living and dining rooms nicely filled the bill. Following the service, parishioners submitted names and took a vote, and Mountain View Lutheran Church was born.

In 1976 Ahwatukee's first food store, a Circle K, opened on Elliot Road east of South 48th Street on the site of today's Walgreens. As Reverend Johnson searched for a suitable location to build a church, Presley Development Company of Arizona offered land either too close to South Mountain, lacking the visibility, parking and multipurpose access that Johnson deemed essential, or too close to Circle K, in potential violation of a county ordinance regarding separation of church and liquor. Then Presley got religion. As the bicentennial year drew to a close, a three-and-a-half-acre site near the intersection of Elliot Road and 48th Street, just south of Fort Ahwatukee, was agreed upon. The full Warner Elliot Loop had just been paved, and development was slowly spreading west.

April 1977's groundbreaking led to Mountain View's main building being christened that December, three years after that first Christmas Eve service in a parishioner's living room. The parish, and Ahwatukee, now had its first true meeting place. From the beginning, Johnson's philosophy was that his church was there to serve not just his congregation but also the community at large. All were welcome at Mountain View, with many non-Lutherans in attendance on Sunday mornings, grateful for the opportunity to attend Ahwatukee's first house of worship of any kind.

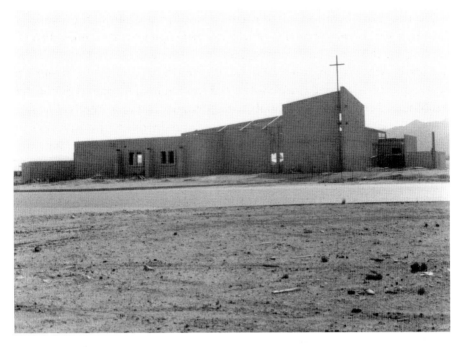

Once open the church, seen here under construction in 1977, ushered in a new level of servant-leadership, helping many other parishes and organizations. *Courtesy* Ahwatukee Foothills News.

Mountain View Lutheran Church served as the catalyst for a strong sense of community in the new development of Ahwatukee. With his mission largely accomplished, Reverend Johnson moved on in 1979 to a position assisting the area's bishop. Reverend Johnson passed away in 1989.

In May 1980 he was succeeded as pastor by Reverend Don Schneider, who adopted his predecessor's philosophy and quickly established himself as a fixture in the community. Said Schneider, "Our legacy is that of community servant. We invited Baptists in 1982 before they started Friendship Church—and they stayed for seven years. Corpus Christi's founding pastor, Father Sigman, held three Masses here each weekend starting in 1985 and ran an educational program. The Episcopalian church was next, and things just mushroomed from there." A driving force behind Mountain View Lutheran's many outreach programs, Schneider built on Johnson's foundation. Mountain View Lutheran's doors were open to the community, with as many as forty different groups ranging from Boy Scouts to adult day care to Alcoholics Anonymous also making the church's facilities their own for meetings and events, thanks to Schneider's generosity.

For ten years the magnanimous pastor was Santa Claus to thousands of Ahwatukee children, annually arriving by helicopter in Ahwatukee Plaza's parking lot the day after Thanksgiving. His youngest son yelling, "You're my Dad!" while sitting on Santa Claus's lap didn't cause him to miss a beat. Absorbing a small preschool of the same name, Reverend Schneider established Ahwatukee Preschool—which counts National Football league players Brent and Zach Miller among its alumni—during his first year in town. As the area grew and other religious parishes sprang up, Mountain View Lutheran was there to help them get started. All religions that sought help had a place in which to worship during their parishes' infancies due to Mountain View Lutheran's open-door policy. Reverend Schneider retired as pastor in 1996 and passed away in 2018. Current Pastor Glenn Zorb has led the congregation since 2008.

From a mix of about 80 percent seniors and the balance growing families in the late 1970s to the opposite mix today, Mountain View Lutheran Church's growth has mirrored that of Ahwatukee Foothills. The typical 125 Sunday service attendees in the late 1970s peaked at around 1,400 in the mid-2000s. As of this writing, the typical 800 Ahwatukee attendees does not include those at two satellite campuses in Maricopa and Sun Lakes.

Today, there are more than a dozen houses of worship in the Village of Ahwatukee Foothills. In the beginning, there was Mountain View Lutheran Church.

TRAVELS OF A TOTEM POLE

One arrived before Rudy Vallee and the other a year before the Beatles, but together they made beautiful music in nurturing a piece of Ahwatukee that spanned the decades between the Roaring Twenties and the early days of the community's development.

After homesteading in the Higley area during World War I, Indiana native Byron Slawson and his general contractor brother, Amos, helped to build Casa de Sueños, the House of Dreams, in 1921. Better known by its botched translation from Spanish into the Crow Indian language, the "Ahwatukee" ranch stood just off today's Warner-Elliot Loop for fifty-four years until it met an unceremonious end via the wrecker's ball in 1975.

Theories regarding other potential origins of the word *Ahwatukee* exist. One holds that it's a corruption of a Crow word meaning "land on the other side of the hill"—perhaps in a reference to South Mountain—and another is tied to the Crow word *awachuhka*, meaning "flat land, prairie." A January 10, 2006 *Arizona Republic* article, which cited extensive research of the name Ahwatukee's origin, concluded, "It appears there's no way to track down how the translation was incorrectly interpreted, or by whom."

Before the seventeen-room, twelve-thousand-square-foot adobe house came crashing down, its care and maintenance was faithfully overseen by Slawson, whose duties as full-time caretaker stretched from shortly after original move-in on Thanksgiving Day 1921 to the death of the ranch's second owner in January 1960. In her will, wealthy spinster Helen Brinton deeded forty acres of her land to Slawson in a life-estate, allowing the former

caretaker to continue to remain in his modest adobe house on the property for as long as he lived.

As the youngest member of Philadelphia's herpetological society, Jim Pinter headed west to Arizona State University in 1963. While a big attraction was ASU's Poisonous Animals Research Lab, Pinter's interests gradually expanded to agriculture, and he ended up earning advanced degrees in zoology and botany. In 1979, Pinter moved into a new Wood Brothers house as close to South Mountain's south side as Ahwatukee development would allow. The research biologist and his wife, Teresa, both now retired, have lived in their Ahwatukee home on the desert's fringe ever since.

Blame it on the beet armyworm. One of the country's most prevalent agricultural pests and the annual cause of millions of dollars in crop damage became Pinter's object of focus as he worked toward his doctoral degree in the early 1970s. Seeking to study the insect in its natural desert habitat, the graduate student needed electricity to power his research equipment's instrumentation. One of Pinter's ASU professors was an acquaintance of Byron Slawson's, and the graduate student and former caretaker became fast friends.

Utilizing the ranch garage's electrical outlets, Pinter ran a one-hundred-foot extension cord into the desert behind the building, which stood at the end of the straight-as-an-arrow dirt path that was Warner Road. In its journey west toward the ranch's garages, the farm road passed through the green cotton fields of the Lightning Ranch to the east of the property—land that would eventually become Presley Development of Arizona's original Ahwatukee core.

In addition to having graded and landscaped the ranch during its early 1920s construction, Slawson over the years single-handedly built hiking and horseback riding trails up into South Mountain, gathered colorful desert plants and boulders to control erosion and constructed an elaborate cactus garden near the ranch house. During the 1930s and 1940s, Slawson's caretaker's duties occasionally encompassed an excursion to Mexican missions to find and bring rare varieties of non-native cacti back to Arizona. The latter included local specimens as well as exotic varieties from California, which Slawson procured at the behest of Ahwatukee owner Helen Brinton—she of the botched translation from which the village arguably takes its name.

Pinter's time at the Ahwatukee Ranch involved many enjoyable afternoons spent with the octogenarian Slawson. The ASU graduate student remembered the former caretaker as "a wise and gentle elderly man who knew a lot about the area. He had a lot of recollection about the way things

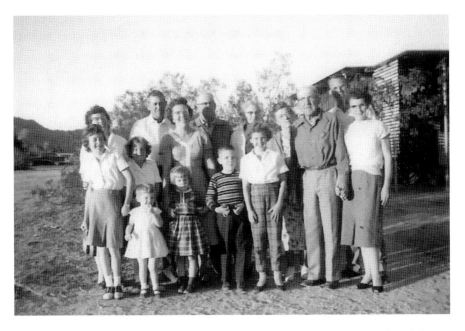

Byron Slawson (*front row, second from right*) gathers with family at the Ahwatukee Ranch in 1959. *Courtesy Burma Slawson Evans family collection.*

used to be and a folk wisdom regarding the desert plants, their names and the connection between the area's flora and fauna."

The small adobe house in which Slawson and his wife, Matilda, had raised five children was "packed with stuff," said Pinter, but every object and artifact had an interesting story connecting it to the area's history. Old wagon wheels and related parts collected dust in the ranch house's garage, along with a mint-condition, early 1950s Cadillac sedan owned by Brinton. Slawson never drove the vehicle, which sat in its dusty entombment for years.

In 1972 Pinter received a gift from a proud Byron Slawson: a singular twelve-inch-tall totem pole cactus from the Ahwatukee Ranch's garden. The appreciative Pinter planted the totem pole—a cactus characterized by a smooth, green, thornless surface and small knobby protrusions—in the front yard of his south Phoenix home. When Pinter moved into the new development of Ahwatukee, north of Elliot Road, seven years later, the now three-and-a-half-foot totem pole came along for the ride.

For the next thirty-three years, that is where it grew and thrived. The research biologist's desert landscaped backyard was ideal for the multi-branched plant, which ultimately grew to a towering twelve feet tall with a girth almost as wide. The Ahwatukee Ranch house sat empty during the

1960s. By the time Pinter arrived on the scene, a few ASU coeds, one whose father headed the land syndicate that had purchased the property, were living in the big house (see page 107). Huge parties, at least one of which got advance billing over ASU's campus radio station, shattered the desert's tranquility—and in the process hastened deterioration of the once-grand residence. Both the amiable Slawson and the studious Pinter could only watch and wince before Pinter completed his research and moved on.

When the end came, Byron Slawson was moved to tears. The old ranch house—that magnificent structure that he had helped to build half a century earlier but by then reduced to a high-maintenance relic—was bulldozed by Presley Development Company in 1975. With it, the transformation from pristine desert and its sleepy agricultural environment to a residential community was underway. Slawson died a year later at the age of eighty-four.

The caretaker's gift from the Ahwatukee Ranch paralleled the growth of Ahwatukee itself, as the eventual village grew from its original modest size to add additional communities and encompass almost thirty-six square miles. January 2013 brought heavy winter rains, and Jim Pinter's totem pole cactus's shallow root system could no longer support the massive plant. The totem pole toppled over in the rain-soaked ground. Jim and Teresa Pinter cut the cactus into small sections, and at least one of them, an eighteen-inch specimen similar to the one given by Byron Slawson to Pinter in 1972, lives on. Fittingly, it now graces the front yard of the hometown newspaper's founder, former editor and longtime Ahwatukee resident, Clay Schad, who was instrumental in promoting the fledgling community during its early and rapid-growth years.

Longtime Ahwatukee resident Jim Pinter stands behind his totem pole cactus, souvenir of the Ahwatukee Ranch, shortly after winter rains in January 2013. *Submitted photo.*

It was April 1973 when Presley held the grand opening of its initial model homes, thereby ushering in the first master-planned community on the south side of South Mountain and the strange word *Ahwatukee* into the Valley's lexicon. Like a certain totem pole cactus that keeps moving to stay alive, it continues to thrive despite the occasional winter rain.

THE PROVING GROUNDS

"Are you reliable?"

"Well, I sure hope so. I never have been fired before—I got laid off but I never have been fired."

"OK, you start tomorrow morning. But let me tell you one thing: When you come in here, after you punch that clock you hit that coffee pot—'cause I like coffee all day long—and I like it strong."

"Well, I don't make coffee."

"You better learn!"

And thus, with the niceties of the job interview out of the way, Jack Owens commenced working at International Harvester Company's Proving Grounds in 1952. Starting as a janitor, Owens, member of a third-generation Kyrene farming family, was ranked as one of the company's top mechanics by the time he retired in 1981. His twenty-nine-year International Harvester career loosely paralleled that of the proving grounds itself.

Known throughout the Valley as highly desirable master-planned communities, The Foothills and Club West have been with us now for over twenty-five years. With their still-fresh subdivisions, custom homes and proximity to South Mountain, it may seem as if they've always been there. Jack Owens, who died in 2013, could've told you otherwise.

During World War II, the future International Harvester Proving Grounds had been used by General Motors to test the performance and durability of

its air filters in U.S. military tanks used in North Africa. The rocky terrain, abrasive granite dust and extreme temperatures duplicated nicely the harsh conditions in which Allied forces found themselves overseas. Prior to that the desert land was undisturbed, used in the 1930s for the occasional picnic by a few hardly Kyrene farming community residents.

After the war, International Harvester Company began leasing almost two thousand acres west of today's South 24th Street and north of Pecos Road. A press release on Christmas Eve 1946 announced the news:

> *The leasing by the International Harvester Company of a tract of 1,920 acres of land near Phoenix as a site for experimental testing activities of industrial power equipment was announced today by N.T. Reishus, general manager of the company's Industrial Power Division in Chicago. The land, formerly used as a tank-testing site during the war, is located approximately 23 miles from Phoenix, south of South Mountain. It has been leased for a period of five years from the Arizona State Land Department.*

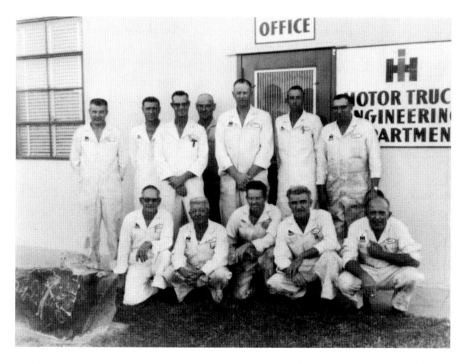

Jack Owens (*left*) and his co-workers had birds-eye views of the future Foothills and Club West in 1975. *Courtesy Jack Owens.*

Said Mr. Reishus, "For some time Harvester has been searching for a site where experimental engineering and testing could be carried out throughout the year. In addition, we wanted a location where large portions of earth could be moved without damaging the land. Our Phoenix testing grounds is ideally suited for these purposes and we are assured a maximum number of working days per year."

Three years later, Harvester increased the acreage to 4,140, adding its motor truck division to the mix. Per the company's September 22, 1949 press release: "A tract of land consisting of more than 4,000 acres, located about 23 miles south of Phoenix in the foothills of the Salt River Mountains [as South Mountain was also known] will become the site of International Harvester's combined test facility for its Industrial Power and Motor Truck Divisions."

Once again, the division's general manager elaborated:

Since the test and construction work began in 1946 many miles of roadways have been built throughout the area and it is upon these roads that International motor trucks will be tested. There are two reasons for carrying out our test work in Phoenix. The first is that the area lends itself to our needs. Arizona's climate means no "down" days due to weather and we can drive our trucks there almost constantly. The second is that we can make full use of the facilities. A network of highways has been constructed, all of which are ready for our immediate use.

"The terrain provides us with the ultimate in test conditions, from smooth, level areas needed to test trucks at high speed to rough, steep inclines that challenge the endurance and power of our products," noted another division manager at the time. The network of roads constructed during the previous three years of power equipment testing was put to use when the trucks arrived. Among them was a seven-and-a-half-mile oval track, paved in 1953, over which parts of today's Desert Foothills Parkway and the former Pecos Road were built.

With Williams Field Road (now East Chandler Boulevard) benefiting from the road paving done primarily for west Mesa's air base, local farmer Richard Evans recalled watching caravans of trucks carrying crawler tractors, bulldozers and earth-moving machines slowly rumbling past the Collier Evans Ranch (see page 82) on occasion from the 1950s through the early 1980s, headed west to the proving grounds. Evans benefited from the facility's next-door-neighbor proximity, as Harvester enlisted him to periodically test farm equipment on his ranch. Evans echoed local farmer Eli Gates's sentiment that "we thought the proving grounds would be there forever."

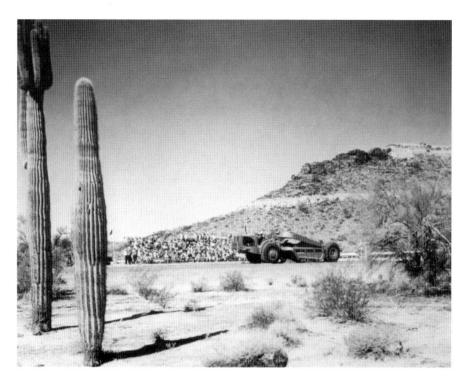

Harvester made full use of the proving grounds, demonstrating its earthmoving equipment in front of visiting dignitaries in 1954. *Courtesy Wisconsin Historical Society, WHi39932.*

Harvester's 1968 purchase at auction of the land that it had been leasing brought $1.6 million into Arizona's State Land Department's coffers. Five years later, the Arizona legislature set aside $5 million for construction of an Arizona Correctional Training Facility on 320 acres of state-owned land bordering the west side of the eventual Club West. Wrote Robert Pickrell of Phoenix's Stewart & Pickrell Ltd. in an August 1973 letter to counsel for International Harvester, "The money for the prison [$5 million] has been appropriated and they are now awaiting final plans before proceeding." Those plans were never finalized, and the facility wasn't built.

A $27 million patent infringement award to rival John Deere Company forced Harvester to put the property up as collateral in 1982. Placed into escrow the following year, the proving grounds was marketed as Pecos Ranch and purchased by Phoenix developer Robert Burns of Burns International Company for about $5,000 per acre in January 1984. It was, at the time, the largest single real estate transaction between one buyer and one seller in

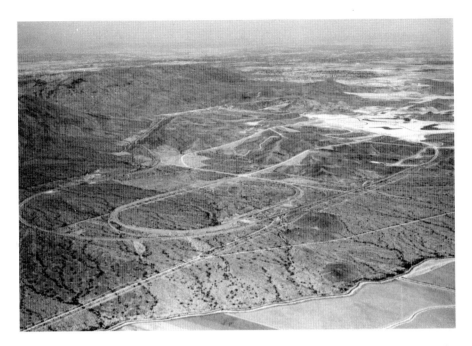

The Foothills golf course is under construction (*far right*), with the future Club West (*near left*), designated Phase III of the project. *Courtesy Jim Spadafore.*

Phoenix history. Mike Longstreth, first project manager of Mountain Park Ranch, observed, "At that price you had to calculate the usable area, since only a limited amount of the property had usability. Burns might have paid two to three times what market-value would have been had it been flat land. Of course, the substantial positive of having the mountain so close likely outweighed the usability issue."

While his job involved rough work and often scorching temperatures, Jack Owens enjoyed the camaraderie that his career with International Harvester afforded him. His coffee-making ability didn't improve much beyond his initial job interview, but then his first boss didn't exactly sport a gourmet palate. Owens's twenty-nine years on the job witnessed a scarring of the land that could only have been allowed to happen on a proving grounds, but for him it was the natural beauty of his surroundings that resonated. Owing to its remote location and status as a tank, power equipment and truck-testing facility over the course of forty years, Burns Vice-President of Sales Jim Spadafore succinctly recalled his initial impression upon viewing the property for the first time. "It looked," he said, "like a nuclear test site."

SOMETHING IN THE AIR

*T*hat's entertainment! Sipping his morning coffee, waiting at the red light on Elliot Road at 56th Street with the few other cars headed west toward the freeway or Ahwatukee, Mark Salem couldn't help but laugh. The biplane barreled down the runway, looking for all the world like it was going to continue right into the line of cars, when at the very last minute it became airborne, barely clearing the vehicles' rooftops. The pilot could have pulled up earlier, but what fun would that have been? Salem, manager of Ahwatukee's first gas station, smiled as he recalled the terrified faces of the vehicle occupants as they anticipated the arrival of a biplane through their passenger-side windows.

No-holds-barred takeoffs were all in a day's work at Sanders Aviation. Led by Rowd Sanders, a fellow as dedicated to having fun as he was to running a successful business, the mini-airfield served as the base of operations for a small fleet of biplanes that sprayed the crops in and around the Kyrene farming community during the years when agriculture defined the southeast Valley.

Born in Safford, Arizona, in 1911, Alfred "Rowd" Sanders's love of flying prompted him to take lessons at Sky Harbor Airport at a time when it consisted of little more than a few hangars and dirt runways. The call of the wild (blue yonder) beckoned when he got his pilot license in the 1930s, and Sanders quit his job just south of the airport at Arizona Sand and Rock a decade later. He opened his own airport in southwest Tempe.

How does one actually open his own airport? In the late 1940s, Sanders acquired two hundred acres of raw desert on the northeast corner of

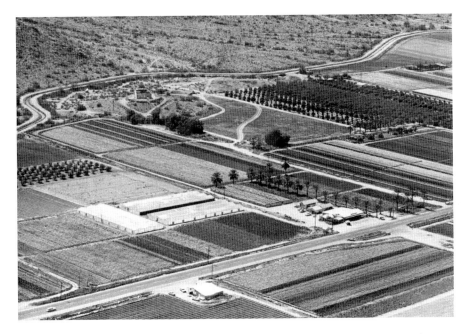

Sanders's crop dusting business serviced many farms in the Kyrene farming community, extending to some of the flower gardens on Baseline Road. *Courtesy Nick Nakagawa.*

56th Street (now Priest Drive) and Elliot Road, just south of the town of Guadalupe, and proceeded to parlay his love of flying into a successful crop dusting business uniquely suited to the Kyrene farming community. A large steel hangar in which Rowd maintained his office and two smaller, Quonset hut–style hangars were built on the northwest corner of the land, with a north–south dirt runway extending from the hangars all the way to Elliot Road. The yellow biplanes with the Sanders name on their sides were neatly parked in a row adjacent to the office.

To facilitate the switch from sand and rock to aviation, Sanders purchased a few surplus Navy N3N biplanes right after World War II and started his own crop dusting business out of his house in Phoenix. In the early days, he and his wife, Pearl, put on goggles and dropped pamphlets to the ground as they flew over the farms of potential customers in and around the Kyrene farming community.

The presence of the Highline Canal—the lifeblood of water for many Kyrene farms—on the eastern border of the property enabled Sanders to plant citrus on about two-thirds of the easternmost portion of the acreage. More citrus covered the land all the way to 56th Street, making the dirt

runway a hundred yards east of the street appear to have been cut through a seemingly endless citrus grove. The color green dominated the view.

Until the mid-1960s, when the construction of Interstate 10 gave the first hint that the land west of the freeway might not always have a rural Tempe mailing address, the crop dusting airport was also used by area pilots for repair and maintenance work and to practice their takeoffs and landings. With his brothers Bob and Budge, Sanders filled a need both on the ground and in the air. Following a 1965 training accident in which the Tempe city manager was killed, use of the airport was restricted to Sanders biplanes only.

By all accounts a well-liked man with a great sense of humor and hundreds of friends, the Will Rogers–like Sanders served on the Tempe City Council from 1962 to 1970. As evidence of the man's irrepressible humor, longtime Kyrene farming community resident Tom Owens recalled Rowd taking him for a ride in one of the open-cockpit biplanes and yelling back from the pilot's seat several times, asking if Owens wanted to do a little stunt flying. An immediate and emphatic "No!" was the white-knuckled Owens's consistent reply, each time a little louder and more desperate. Finally, Sanders gently flipped the plane into an upside-down position, laughing all the while as his terrified passenger held on for dear life. Owens's reaction, once safely on the ground, helped the pilot to enhance his own vocabulary.

Sanders died in 1980 when his truck left the road north of the Grand Canyon. It was his sixty-ninth birthday. His son, Steve, continued running the business, but it wasn't long before farmers converted their green fields to green wallets and the business's days were numbered.

David DuPree, in his *Vanished Flying Fields*, described the airport's final years:

> *By 1982 it was apparent that urbanization was going to force the closure of Sanders Airport. Fields that Steve's father had dusted or sprayed throughout the Fifties and Sixties were now covered with houses, commercial buildings and schools. Much of the company's business was coming from areas like Queen Creek, which required flying long distances through high-intensity airspace. Inevitably, in the latter half of 1984, two big X's were placed on the runway and Sanders Airport was officially closed. The City of Tempe, which had finally annexed the former county island, wasted no time in commencing construction of Grove Parkway. This road sliced across the Sanders runway and was completed in 1985. The area surrounding the*

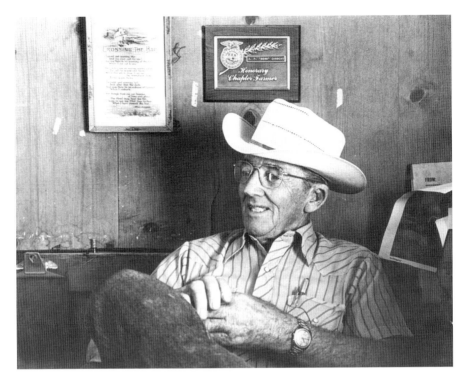

Alfred Perry "Rowd" Sanders at his desk in the mid-1960s. His biplanes were common in the skies over the Kyrene farming community. *Courtesy Susan Livingston.*

intersection of South 56th Street [now Priest Drive] *and Elliot Road has undergone an incredible transformation....Even as late as 1986 both streets were bumpy, two-lane country roads and the corners were still undeveloped. Around 1987 Tempe embarked on a major street-widening project and in 1991, a giant Wal-Mart plopped itself down on the south end of the old runway. This has been followed by an almost frenzied level of residential, commercial and industrial development. Today* [mid-1990s] *the area is unrecognizable.*

When Rowd Sanders first learned of Randall Presley's prospective development of the Tempe property, his first reaction was, "What in the world are they buying that way out here for?!" But times change, and the area's fields and green crops, and indeed the Kyrene farming community itself, have long since been replaced by houses, tiled roofs and paved roads, eliminating the need for crop dusting operations such as Sanders's. For

more than thirty years, Sanders Aviation's low-flying biplanes serviced the farms in and around the community and were as much a part of the skies, both over Ahwatukee Foothills and off in the distance on the other side of the freeway, as are the ubiquitous convenience stores that dot the landscape at ground level today.

ONE RULE: HAVE FUN!

There were no rules, which may be why it worked so well. With an ad hoc crew of Presley Development Company of Arizona personnel, construction subcontractors and assorted helpers gathered in and around Fort Ahwatukee, a tradition of spirited revelry, seasonal celebration and spring pageantry was born. Happily, it continues to this day.

The mid-1970s had witnessed a sharp downturn in the housing industry, affecting developers nationwide. Presley, Ahwatukee's developer, was caught in the slump just like everyone else. The bicentennial year of 1976 saw staff meetings focused on brainstorming ways to generate interest and jumpstart sales in the still small and remote community of Ahwatukee. As Presley's vice-president of construction, Lew Wilmot, recalled, "We were watching an Easter Parade somewhere back east. It was cold, the wind was blowing and the ladies had their Easter bonnets on—but they were tied on. I looked out the window and it was beautiful here. Perfect weather!"

Many parades elsewhere seemed more of an endurance test involving braving the elements than ones of carefree celebration. In stark contrast, the desert Southwest usually offered Easter weekend weather—indeed, most all of spring's—that was typically gorgeous. Thus inspired, Wilmot pitched the idea of Ahwatukee staging its own Easter Parade to Bruce Gillam, Presley of Arizona's president. Gillam's only question: "How much will it cost?" The two businesses around, Ahwatukee Insurance Agency and Circle K, each donated $2,500, which Gillam matched. The ad hoc parade committee ultimately used the proceeds to stage and promote the event and award prizes.

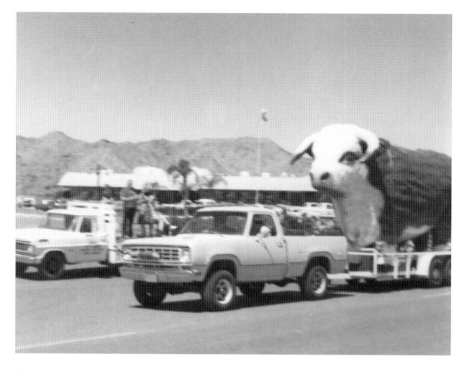

There was no missing the Earnhardt bull as it rolled down South 48th Street past the Ahwatukee Country Club. *Courtesy Pete Meier.*

Saturday, April 9, 1977, dawned reliably blue-sky sunny—the perfect weather. The Ahwatukee Jay-Cees, a young men's leadership organization, lined up several of the relatively few entrants in that first parade with help from its sister club, the Jay-Tukees. Bunny-costumed kids from Ahwatukee Preschool rode in the back of a pickup truck. There were Brownies and Cub Scouts, a ten-foot-tall replica of the Earnhardt bull on a flatbed truck, a contingent from the newly opened Kyrene de las Lomas elementary school and a few local street vans. With its initial entry, Mountain View Lutheran Church (the parish, not the building, which had just broken ground) initiated its status as the only entrant to have participated in all forty-one Easter Parades as of this writing. In all, about twenty entries were cheered on by perhaps a hundred spectators during that first parade.

But the highlight of the event was the grand float—indeed, the parade's *only* float—fabricated in Fort Ahwatukee the day before the event. The construction equipment storage stockade on the southwest corner of Elliot Road and South 48th Street (site of today's Ahwatukee Mercado shopping center) served as

home base for the motley crew of Presley employees, contractors and assorted minions, many of whom worked through Friday night using materials donated by Presley and a few of its subcontractors. With liquid refreshment topping the list of essential supplies, the crew painstakingly fashioned a giant Easter basket on wheels, bolting two golf carts together, attaching PVC pipe bent to form the basket's skeletal frame and covering the frame in chicken wire and colorful crepe paper. Randall Presley, on hand for the festivities, did his share by pitching in. Giant papier-mâché eggs and bouquets of fresh flowers served as the float's exclamation points.

Presley secretaries Linda Whelan and Evie Ziegler, wearing southern belle gowns rented from (where else?) Acme Rentals, served as parade queens. But after all the crew's hard work, one giant problem remained: at twenty-eight feet in diameter, the float was too big to fit through the fort's gate. Dismantling the float was out of the question, so with only twenty minutes to spare, the fort's gateposts were removed. Everyone stood admiring their handiwork before realizing that the float was too tall for the ladies to climb

Ohio Spring visitor Mary Skipper viewed the parade, heading south on South 48th Street, from her daughter's backyard. *Courtesy Jan Radcliffe.*

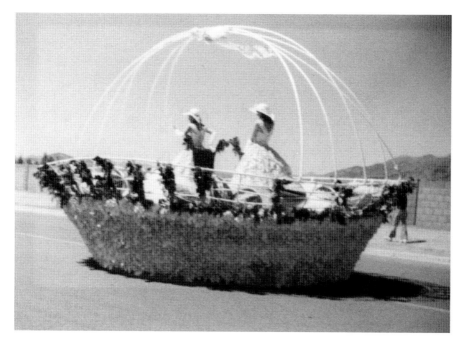

Nearly twenty-four hours in the making, the only float in the first parade had Presley secretaries Linda Whelan and Evie Ziegler riding high. *Courtesy Marla and Lou Wilmot.*

onto. A male crew member fetched a ladder, and as he assisted one of the beauty queens in her ascent a sudden gust of wind resulted in his head being buried beneath her dress. Fate works in mysterious ways, for, truly, they were married shortly thereafter.

Ahwatukee's first Easter Parade served as a unifying event in the community. Many of the spectators who turned out to cheer on the participants had family and friends living elsewhere who might be interested in living in Ahwatukee, or so Bruce Gillam's thinking went. TV coverage of the event heightened Ahwatukee's profile in front of the home-buying public while helping to strengthen the sense of community among residents. For safety reasons, the City of Phoenix had the route reversed early on from its march south on South 48th Street, deciding that crowd management after the parade flowed smoother with a Warner-to-Elliot south–north march.

Ahwatukee had a winner. The parade quickly grew and became one of the community's enduring traditions. Over the years, entrants ranging from a five-year-old boy covering the entire 1.1-mile parade route on his decorated-for-the-occasion Big Wheel, with his sister in tow behind him,

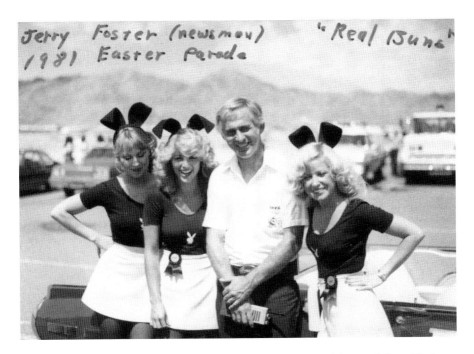

Local traffic reporter Jerry Foster and three attendees from Phoenix's now-defunct Playboy Club were among the 1981 parade's participants. *Courtesy Marta and Lou Wilmot.*

to Phoenix's Playboy Club, as well as Shriners and civic organizations, have marched in the parade. Radio personalities, elected officials and the founder of the village's local newspaper have all served as grand marshals in years past. Today, spectators total around 10,000 people, with about 2,500 participants involved in seventy-five to eighty formal entries. From almost the beginning, the festivities have continued at a post-parade Spring Fling at nearby Ahwatukee Park, where everyone from Wallace and Ladmo to local musicians have entertained the crowds in a party-in-the-park atmosphere.

The Ahwatukee Chamber of Commerce succeeded the Jay-Cees as parade sponsor, but a potential religious-event conflict limited its involvement to just one year. Ahwatukee's Kiwanis Club assumed sponsorship in 2001 and continues as a co-sponsor today. And no history of Ahwatukee's Easter Parade is complete without the name Mike Schmidt, the person who has been instrumental in organizing the event since 1980. As parade boss Schmidt devotes about two hundred hours over six months to pre-event planning as he solicits entrants, tends to crucial administrative tasks, fine-

Celebrities Wallace and Ladmo provided post-parade entertainment during the early years of the Easter Parade festivities. *Courtesy Pete Meier.*

tunes the logistics and writes the scripts that are announced for every formal entrant. The latter task alone encompasses fourteen hours.

The can-do attitude, entrepreneurial spirit and neighborly camaraderie, so characteristic of the community's early days, was never more evident than in the days leading up to that first parade. Spawned by a gray TV image in 1976, the pageantry and celebration has become a long-standing fixture in what is now the Village of Ahwatukee Foothills. As with the village's annual Festival of Lights celebration, the eagerly anticipated parade draws attendees from near and far. When the next Ahwatukee Foothills annual Easter Parade marches up South 48th Street, look closely: Is that yellow, pink or blue crepe paper decoration fluttering by a lingering remnant of that first Easter Parade float?

WHAT MIGHT HAVE BEEN IN
MOUNTAIN PARK RANCH

*A*mong the master-planned communities in the Village of Ahwatukee Foothills, Mountain Park Ranch stands out for its unique foothills desert setting, which was only enhanced by creative landscaping as the community developed. But more than fifty years before development occurred, Dr. Alexander Chandler, founder of the city that bears his name, recognized the enormous potential of the pre–Mountain Park Ranch and purchased a substantial portion of the land in its native desert state.

Founder of the historic San Marcos Hotel ten miles to the east, Dr. Chandler dreamed of building a grand resort in the South Mountain foothills, one that would surpass his stately San Marcos in both scope and majesty. Opened in 1913, the City of Chandler hotel quickly established itself as a vacation destination for the rich and famous and played a significant role in ushering in Arizona's tourism industry. During the 1920s, Dr. Chandler's Chandler Improvement Company acquired large tracts of land in the eventual Mountain Park Ranch and The Foothills, including a large swath near the future master-planned community's southwestern border. North of present-day Desert Vista High School and not far from the current intersection of South 32 Street and East Chandler Boulevard, Chandler chose a six-hundred-acre location for his three-hundred-room resort, to be known as San Marcos in the Desert.

America's preeminent architect, Frank Lloyd Wright, had created the exterior facing of Phoenix's Arizona Biltmore Hotel in 1928. Chandler

commissioned Wright to design his project for the then princely sum of $40,000. Against the South Mountain backdrop, Chandler's resort would incorporate a block exterior that would closely mimic the flutes of the saguaro cactus, blending seamlessly into its pristine desert surroundings.

Wright's party of fifteen included his wife, Olgivanna; daughter, Iovanna; stepdaughter, Svetlana; and a team of architects and set out from his Wisconsin headquarters in a blinding snowstorm in January 1929. Upon arrival in the future Mountain Park Ranch, Wright built a makeshift camp on a knoll overlooking the resort site, just north of the future Desert Vista High School, from which he would oversee construction once it began. In near-perfect weather, Wright used the camp as both lodging and work quarters for his group.

Camp Ocotillo, alternately spelled "Ocatillo" and "Ocatilla," was so named by the architect's wife because its triangular buildings resembled the native ocotillo plant. The camp consisted of fifteen small wooden cabins surrounded by a low wooden wall enclosing its perimeter. Since the knoll was not level, each structure contained a raised wooden floor. Wright experimented with light canvas and screens in place of traditional windows and a roof over each cabin. Painted a dusty desert rose, the compound would serve as inspiration for Wright's Taliesin West in north Scottsdale a few years later.

A March 21, 1929 *Chandler Arizonan* headline proclaimed, "San Marcos in the Desert Will Be Nation's Finest Hostelry." The story's author, who had accompanied Dr. Chandler on a tour of the locale, wrote, "And then Dr. Chandler…led me from spot to spot and explained how this pinnacle would be crowned by a structure and that slope softened by another, and how the already plentiful scattering of native saguaro cacti and the gaunt ocatilla and the cholla would be reinforced by transplanting more of those species—to make a desert garden such as God in His own lavishness might have planted there."

As the weather warmed, rattlesnakes and spiders soon outnumbered the campers. When the group broke camp in May for the summer, Wright's design of the $480,000 resort was complete. His intent was to return to camp the following winter when construction started, and a local resident was enlisted to stand guard over the summer. But the October stock market crash wiped out Dr. Chandler and his investors. The resort was never built.

How different would Ahwatukee Foothills look today had San Marcos in the Desert come to fruition? North of Desert Vista, west of Chandler Boulevard and east of Vista Canyon Park, the knoll on which Camp Ocotillo

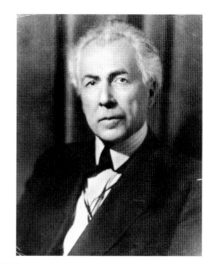

Right: Frank Lloyd Wright, pictured here in 1930, spent parts of the winter and spring of 1929 on the future Mountain Park Ranch. *Courtesy Frank Lloyd Wright Archives, Taliesin West.*

Below: Camp Ocotillo, where Wright and his team drew up plans for Dr. Chandler's desert resort. *Courtesy Frank Lloyd Wright Archives, Taliesin West.*

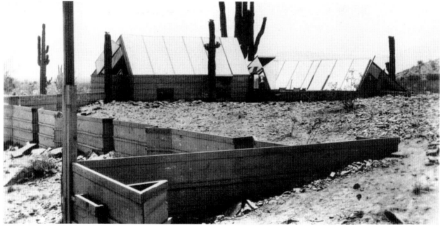

stood remains and is now surrounded by houses, with all but a few scattered wooden scraps remaining. Although the area is now developed, the knoll itself is largely unchanged from when first viewed by Frank Lloyd Wright. Surrounded by houses today, it bears mute testimony to a Mountain Park Ranch that the visionary Dr. Chandler saw as his unpainted canvas some ninety years ago.

FIRST NAME IN RETAIL

S omeone had to be first. Millie Wynberg, who together with her husband, Hank, founded Millie's Hallmark on Elliot Road in the late 1970s, will forever hold a special place in Ahwatukee Foothills history for her role in the number of "firsts" that she and her store achieved.

After long and distinguished careers in the education and trucking industries, Chicago retirees Millie and Hank Wynberg, respectively, faced a tough decision: to play cards or to sell them. In actuality, neither Hank's thirty-eight-year career in the trucking industry, begun behind the wheel in the late 1930s at the princely salary of eighteen dollars per week, nor Millie's eighteen-year elementary school teaching career prepared them for the card business. So, with due diligence but no retail experience, the couple in their early sixties opened a greeting card store in a remote community of which few had ever heard.

A few short visits with friends in the Ahwatukee vicinity had convinced the Wynbergs of the desert Southwest's charms. Potential store locations in the Tucson area were considered, but ultimately—as was the case with many other midwesterners during the young community's early years— Hank and Millie decided on Ahwatukee. "It was an out-of-the-way place but had potential for growth with both Tempe and Chandler close by," Hank recalled.

Rather than franchising, Hallmark Corporation simply required that a certain percentage of its products be carried in a store in exchange for the use of the Hallmark name. In the spring of 1978, the Wynbergs' path

Millie and Hank Wynberg took a chance on Ahwatukee, getting more than they bargained for in retirement. *Courtesy Linda and Tom Olson.*

converged with that of another early Ahwatukee visionary, Bill Grace. As the man whose company was among the Southwest's premier commercial real estate developers and whose name for many years graced the hotel built in 1985 just off South 51st Street at Elliot Road, Grace was in the process of constructing Ahwatukee Plaza, which would become Ahwatukee's very first shopping center, on the southeast corner of Elliot Road and South 51st Street. "We knew that a shopping center would be built. We signed an eleven-year lease because the rate was very low. We could have lost big, but it really paid off for us," said Hank.

Joining anchor tenant and Ahwatukee's first supermarket-to-be, Alpha Beta, the Wynbergs leased a 4,000-square-foot storefront in the as-yet-unfinished Ahwatukee Plaza. Hallmark, accustomed to an average new store size of 2,600 square feet, balked at the larger size in such an unproven location. But the need to continually enlarge undersized trucking terminals combined with Hank's executive experience negotiating with Chicago teamsters to convince Hallmark that the area's potential warranted the larger space.

With the opening of a Mobil gas station across South 51st Street in October 1979, the number of Ahwatukee's retail outlets doubled—from one

(Circle K) to two. One month later, having completed a weeklong training program at the company's Kansas City, Missouri headquarters, Millie's Hallmark made it three, as the first tenant in the first shopping plaza in the future village. Alpha Beta and a few other tenants opened their doors shortly thereafter, and with much fanfare, publicity and an unmistakable sense of having hit the big time, Ahwatukee Plaza's first shopping center's official grand opening occurred on January 19, 1980.

What was life like for Ahwatukee's pioneer retailers? The future Ahwatukee Foothills consisted of fewer than two thousand people, residing in and around the Warner-Elliot Loop. Millie's uninterrupted view across Elliot Road went clear past the new Rustler's Rooste restaurant and all the way to Camelback Mountain. Truth be told, said Hank, "We had lots of doubts. We had to have a lot of faith."

In sharp contrast to today, Ahwatukee offered three places at which to dine (using the term loosely): the Ahwatukee Country Club and, depending on which direction one walked across Ahwatukee Plaza's parking lot, Roggerio's Pizzeria and Circle K. For years, Millie herself made the three-minute commute from her home to the store in a golf cart, feeling perfectly safe on the sparsely traveled South 48th Street. "Now," she said in 2005, "forget about it!"

An hour's wait between customers was the rule in the early days, and it would be three years before Millie's Hallmark made a profit. That view clear all the way to Camelback Mountain helped pass the time. But Millie's soon landed a contract with the postal service, and with it, traffic flow increased. The store served, in effect, as Ahwatukee's first post office, making Hank the village's unofficial first postmaster.

Under the headline "Post Office Coming Soon," the March 1980 edition of *Ahwatukee News* reported that "Mr. Henry Wynberg, proprietor of Millie's Hallmark Card Shop, activated plans to have a section of his store converted to a post office. In addition, Mr. Wynberg is scheduled to attend a class conducted by the Postal Department for indoctrination of rules, regulations and how to run a post office efficiently." By the time the hamlet's first true post office opened in the summer of 1983 in a small Ahwatukee Plaza storefront a few doors down from Millie's, the Hallmark card store had gained a strong following and added collectibles such as Precious Moments to its inventory.

Along with Mobil station manager Mark Salem, Hank founded the Ahwatukee Merchants' Association, which was a precursor to the village's chamber of commerce. Together, Wynberg and Mountain View Lutheran

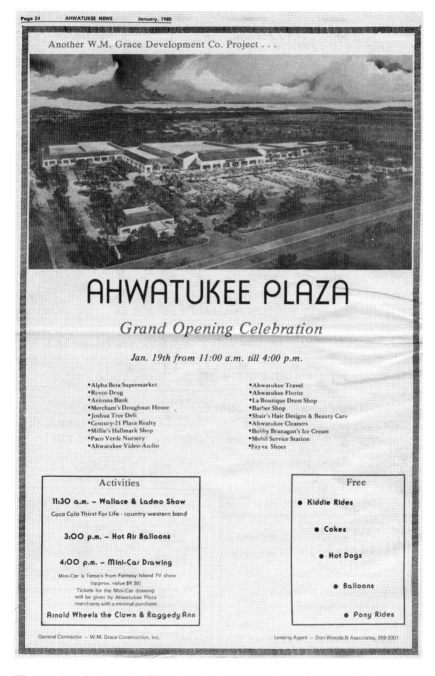

The opening of Ahwatukee Plaza brought the master-planned community its own grocery store, ending many residents' shopping trips into Tempe. *Courtesy* Ahwatukee Foothills News.

Church pastor Don Schneider founded Ahwatukee's Kiwanis Club in late 1981. That same year, Salem arranged for local traffic reporter Jerry Foster to fly Santa Claus—who for the next ten years bore a striking resemblance to Reverend Schneider—by helicopter from Sanders Aviation, just across the freeway, into Ahwatukee Plaza's parking lot on the day after Thanksgiving. Greeted there by Mrs. Claus—who for the next twenty-five years bore a striking resemblance to Millie—what was to become the area's longest-running annual Christmas tradition was born. For many years, the *Ahwatukee News'* two biggest advertisers were Presley Development of Arizona and Millie's Hallmark Card Shop.

Hank credited his wife for much of the store's success. With a nod to the couple's age and the fact that many workers were first-job high school students, Hank offered that Millie had a special gift. As a grandmotherly type who could be stern when needed, she had a knack for influencing their employees to bend over backward for their customers. Saying, "If they didn't learn it here they might not learn it at all," Millie firmly

Embracing its role as a fixture in the community, Millie's Hallmark was a staple of the annual Easter Parade. *Courtesy Linda and Tom Olson.*

but affectionately drilled her young charges in punctuality, honesty and courteousness, teaching them valuable life lessons in the process.

Observing how times have changed, Millie recalled two mothers, each regular customers of the store, who had brought in their teenage daughters upon learning that they'd shoplifted a few trinkets. Hank Wynberg arranged for Mike Collins, owner of Ahwatukee Security, to stop by wearing his Sunday-best security officer uniform in order to provide a gentle lesson in doing the right thing. Motioning to his handcuffs Collins told the girls, "I could arrest you" but said that he was giving them a second chance. Hank quietly took the girls' mothers aside, saying, "I want these kids to never do that again. I want them to understand the consequences of their actions." Asked Collins years later, "What business owner takes the time to do *that*?!"

As the community grew and business increased the Wynbergs found themselves working upward of seventy hours a week. Millie and Hank both realized that the store was a lot more work than the retirees had anticipated. Enlisting their daughter, Linda, as store manager, they groomed her to run the business before she and her husband, Jack Olson, purchased it in 1987.

The Wynbergs retired for a second time, that year. Under the Olsons' stewardship store expansion reached ten thousand square feet, and Hallmark recognized Millie's as among its top 200 U.S. outlets. A succession of owners followed the Olsons' sale of the store in 2005. Millie passed away at eighty-nine in 2007, three days shy of the couple's sixty-seventh wedding anniversary. Hank passed away the following year.

Some forty years after Hank and Millie made their leap of faith with that eleven-year lease, Millie's Hallmark Card Shop remains a staple of Ahwatukee Foothills retailing. The next time you're driving on Chandler Boulevard, Ray Road or any other major village street, consider the scores of retail outlets all around you. Someone had to have the vision to open Ahwatukee Foothills' first store in its very first shopping plaza. That someone was Millie.

WATER, WATER EVERYWHERE

*I*n the desert, it's all about water. Abraham Lincoln's 1862 signature on the Homestead Act began the piecemeal settlement of the country's vast and desolate land west of the Mississippi by enacting a law that gave settlers land in exchange for their sweat equity. Build a house and live in it and cultivate some of the acreage and, typically, a quarter-section (160 acres) was yours for the keeping.

But how does one farm or, indeed, live in a hostile desert? Jack Swilling's Irrigation and Canal Company dug the first series of canals in 1867 in the path of ones dug centuries earlier by the Hohokum Indians. These enabled settlers in Swilling's newborn city of Phoenix to irrigate crops by diverting water from the mostly flowing Salt River. But it was feast or famine in the Arizona Territory, as the Salt River alternated between overflowed banks with soggy crops in wet years and a relative trickle with parched plants in dry ones. Absent an effective water-storage system drought often prevailed, making survival under the Homestead Act a dicey proposition.

To this cycle of unpredictability came the Newlands Reclamation Act in 1902. Setting aside funds from the sale of government land to finance water management projects, the act succeeded in *reclaiming* hostile desert land for agricultural use by harnessing the watershed runoff of thirteen thousand square miles above Phoenix stretching from Chino Valley down to New Mexico. Bolstered by the ascension to the White House of visionary reclamation proponent Theodore Roosevelt a year earlier, the act prompted construction of Roosevelt Dam some seventy-six miles

northeast of Phoenix. President Roosevelt was there to help dedicate the dam in 1911.

Realizing that they had to work together, local settlers had formed the Salt River Valley Water Users Association prior to dam construction. About 4,800 landowners pledged a combined 248,000 acres as collateral to the federal government. With water and power revenues generated once the system was operational, the $11 million debt was paid in full by 1955.

Marshall Trimble, Arizona's official historian, views Roosevelt Dam's construction as *the* major milestone in Arizona's history. A series of canals transported water from the reservoir created by the dam and a series of similar ones into the Valley. Major canals named the Kyrene, Western and Highline sprang up and became the lifeblood of settlers in what would come to be called the Kyrene farming community. With a predictable water supply, pioneering homesteaders began farming near the future Ahwatukee Foothills during the first decades of the twentieth century. Two of them were named Elliott and Warner.

Continuous irrigation combined with minimal aquifer depletion resulted in land near Rural Road, the lowest point in the Valley, developing a water table so high that by the 1920s, "You'd hit water with a posthole digger," recalled longtime resident Tom Owens. Indeed, the original Kyrene School, founded in 1880 by Colonel James McClintock at the intersection of Warner Road and the road that today bears his name, was moved two miles west in 1920 due to perpetually waterlogged grounds. To lower the near-surface water table, a twenty-five-foot-deep Salt River Project drainage canal running the length of Rural Road to the Gila River Indian Community was dug, and for decades the road was known as Canal Drive. The drainage channel remains in use today via an underground culvert.

No such problem, or luck, existed in the future Village of Ahwatukee Foothills. A hard granite shelf extending from South Mountain made water a rare commodity. The Highline Canal served the relatively few farms in the area, but the land's easterly slope meant that only fields on the downside of the canal—mostly east of where Interstate 10 now stands—could be irrigated. Wells or pumps were alternatives on the "high ground," as the entire area was labeled on early canal maps, but pumping water was expensive. By the time the square-mile Collier-Evans Ranch, Lakewood's predecessor, was sold in 1984, the cost to power its irrigation wells had grown to a whopping $22,000 per month. Separately, managing massive drainage due to the land's proximity to South Mountain presented a different but major challenge, to which A. Wayne Smith alludes in his introduction.

With existing wells filling its golf course lakes, head pro Doug McDonald plays the Ahwatukee Country Club golf course in September 1973. *Courtesy Doug McDonald.*

Randall Presley's 1970 purchase of 2,080 acres of "high ground" coincided with Buck Weber moving his well drilling company onto 30 acres of land on what would eventually become the shadow of the Loop 202 freeway at Interstate 10. At the time, the desolate land was purchased from the Taylor Ranch, the largest farming and cattle operation in the southeast Valley. Randall Presley, seeking a source of water in order to develop his land, sought out Weber, second-generation owner of Weber Water Resources and a legend in Arizona's water procurement business.

For decades Weber oversaw a family well-drilling business founded in 1910. Over the years, thousands of wells and irrigation pumps in and around Phoenix, as well as hundreds throughout Arizona and surrounding states, have had the Weber name on them. Son Bernie, now retired, expanded the business into water pumping operations, with Buck's grandson Marty currently serving as chief executive officer. The fourth-generation Weber Group, LC, is the largest water resources company in the state of Arizona. Buck Weber died in 2012 at the age of ninety-five.

Weber drilled five wells up to three thousand feet deep on Presley Development Company of Arizona's land. Some were completely dry, while others had too high a salt content, and no potable water could be found.

A mile in the distance, beyond the Ahwatukee Country Club Golf Course's newly installed pumping station, are the Ahwatukee Ranch buildings in 1972. *Courtesy the Weber family.*

Fortuitously, three wells on the former Taylor Ranch property contained abundant drinking water, and it was from these three, south of today's Ahwatukee Foothills, that the City of Phoenix procured the water that enabled Presley to get started—in exchange for an agreement of future annexation (see page 126). A pipeline was constructed from Weber's land north under bucolic Hunter Drive, in the process prompting a renaming of the dirt road to South 48th Street. Looking back in 2008, Buck Weber opined, "If we didn't have good water here [on his thirty acres] there wouldn't *be* an Ahwatukee."

As population and demand increased over the years, large pipelines and connection to more traditional City of Phoenix water distribution sources occurred. When the village's other master-planned communities were built in the 1980s and '90s, they simply became part of the City of Phoenix's ever-expanding water distribution system. Charles Keating's Continental Homes, upon its 1980 purchase of the property that became Mountain Park Ranch, traded wells that it owned north of Phoenix with the city in exchange for a tie-in to the municipality's water-distribution system.

A majority of acreage on which the Ahwatukee Country Club was built had been farmed during the 1950s and 1960s using wells for irrigation. But the water's high salt content left the soil in such poor condition that by the

Buck Weber (*standing left*) oversees a 450-foot-deep Ahwatukee well in February 1981. It took Weber ninety days to drill the well. *Courtesy* Ahwatukee Foothills News.

time the country club's golf course was constructed on the farmland in the early 1970s, little would grow. After a few false starts, intensive leaching of the soil finally enabled grass and trees to take root. Conversely, a high alkaline content proved to be ideal in the three wells that Weber Group dug at nearby Firebird Lake to the south, providing a buoyancy that helps boats attain speeds unsurpassed on other courses.

With the entire village of Ahwatukee Foothills now tied into the City of Phoenix's water-delivery system, a legacy of those early days remains. In front of the Ahwatukee Foothills Towne Center shopping center and its parking lot on the northwest corner of Ray Road and South 48th Street sits the 1.5-million-gallon water storage reservoir and lift station that for years pumped water north into Ahwatukee. When Randall Presley bought his land in 1970 it extended all the way south to Ray Road—at the time little more than a dusty trail ending about a quarter-mile west of the intersection of the two sleepy dirt farm roads. The only sign of civilization in the immediate area, if one could call it that, was Eli Gates's junkyard on the southeast corner of the otherwise open-desert intersection.

Former Presley vice-president and longtime area realtor Pete Meier remembered a weekend in the fall of 1973 when the water-level regulator

floats in the storage reservoir failed, flooding the surrounding desert and leaving Ahwatukee's handful of residents without water. The Presley Company had little choice but to put the residents up at a Tempe Holiday Inn while it worked on resolving the problem and getting water restored. For the several days that the project was waterless and Ahwatukee a ghost town, Randall Presley—with operations in California, Arizona, New Mexico, Virginia, Washington, D.C., and Chicago—gave his undivided attention to the fledgling development of Ahwatukee, as well as to those residents whom he was paying to stay in a hotel.

Had a crystal ball been available, the lift station might not have been located on what eventually became such a valuable piece of real estate. But at the time of its 1973 construction, the corner wasn't remotely on anyone's list of desirable locations. Water stored and transported from that corner served as a lifeline to Ahwatukee and fueled the growth of our village, helping to transform the serene desert corner into the bustling power center that it is today. As such, it serves as a microcosm of each master-planned community within the village of Ahwatukee Foothills. As in the entire Valley of the Sun, each new community could not survive were it not for the nurturing and growth made possible because of life-giving water in the desert.

THE FIRST THANKSGIVING

*I*f someone yells "Come and get it!" and no one hears, does a sumptuous meal in the desert still count? Be it turkey or roadrunner, that's the operative question with which to commemorate the first Thanksgiving in what would one day become the Village of Ahwatukee Foothills.

The year was 1921, and Thanksgiving Day was move-in day for William and Virginia Ames. Built around an open-air forty-by-seventy-foot courtyard, their brand-new twelve-thousand-square-foot adobe house had seventeen rooms, seven bathrooms and four fireplaces and was replete with solid redwood paneling, wrought-iron candlelit chandeliers and a 1.5-ton refrigeration system. The September 29, 1921 *Chandler Arizonan* referred to the home as the Mystic House, "located 11 miles west of Chandler, far from any other place of habitation," and advised that "it has been reported that curative waters abound in springs near the place." Today, we call it Sequoia Trail and Ahwatukee Drive just off the Warner-Elliot Loop, and a few watering holes can, in fact, be found not far away.

With some cacti still to be planted, Byron Slawson's work as construction laborer on the project was largely complete. His brother, Amos, having served as general contractor during construction, moved on, and Byron wasn't sure where his next project would take him.

Dinner table conversation that first Thanksgiving has been lost to history, but what is known is that Dr. William Ames was born in 1859 to a prominent midwestern physician, became an accomplished dentist in his own right whose contributions to the industry made him both world-

renowned and quite wealthy and, in 1891, cofounded Northwestern University's Dental School.

When failing eyesight limited close-up dental work, Ames invented one of the first gold crown inlays and a dental cement that provided a significant improvement over those of the time. His W.V.B. Ames Company of Fremont, Ohio, manufactured Ames Cement, as well as other dental adhesives used worldwide. By all accounts Ames was soft-spoken, well-liked and a generous philanthropist. Following his 1895 marriage to Virginia Gilmer, herself the daughter of a prominent physician whose family ancestry predates the American Revolution, the couple spent many evenings around the hearth in their midwestern living room contentedly mixing compounds to be used by his company.

Seeking respite from the rigors of his profession, Ames purchased farmland in Libertyville, Illinois, in 1914, and his land eventually grew to eight hundred acres. He loaned substantial acreage to the Women's Land Army of America during World War I, but the rigors of cultivating the land to its full limit during the war years took its toll on Dr. Ames's health. Wintering in Arizona for the first time in 1919–20 resulted in Ames's acquisition of twelve sections of land south of south Mountain at a cost approximating $32,000, or $4 per acre. One section of land encompasses a square mile. He built his Casa de Sueños (Spanish for "House of Dreams"), expecting to spend winters enjoying the mild climate, peaceful desert and company of visiting friends.

But it was not to be. Sixty-two years old and in poor health, Ames became seriously ill in January and passed away on February 23, 1922, barely three months after that first Thanksgiving. His wife, Virginia, continued to winter at Casa de Sueños until her death in 1933. The Ameses' donation of a substantial portion of their land contributes to South Mountain Park's status as the largest municipal park in the country.

Upon Dr. Ames's death Byron Slawson officially became caretaker of the house and grounds, a position in which he would serve through Mrs. Ames's ownership and the twenty-five-year tenure of second owner, Helen Brinton. Along with his wife,

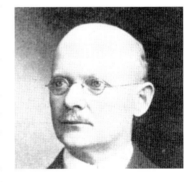

Dr. William V.B. Ames built Casa de Sueños. Alas, his first Thanksgiving in the future Ahwatukee would be his last. *Courtesy Rutherford B. Hayes Presidential Center.*

Virginia Ames continued wintering at Case de Sueños, delighting children at the Kyrene School with her Christmas parties. *Courtesy Burma Slawson Evans family collection.*

Matilda, Slawson raised five children in a small adobe house that Dr. Ames had built for himself nearby during construction of Casa de Sueños. The Slawson family became an integral part of the Kyrene farming community, with their home and the adjacent desert the center of activity for the family's many friends in the small rural hamlet. Finally, after fifty-five years at the Ahwatukee Ranch, Byron Slawson passed away the day before Thanksgiving 1976.

This year, should a lull descend on your Thanksgiving dinner table banter, consider what the scholarly Dr. Ames might have discussed. His "Vulcanized Plates with Flexible Rubber Edges for Securing Better Atmospheric Retention" (1896), "Method of Treating Pyorrhea Alveolaris by Electrolosis" (1887) and "Supplementary Report on Dr. Knapp's Bridgework and Blow Pipe" (1886) were but three of his research papers on which he could rely to jumpstart any conversation. In the tradition of Ahwatukee Foothills' first Thanksgiving, they are guaranteed to put some teeth into your dinnertime conversation and give your guests something besides turkey, or roadrunner, to digest.

A Freeway and a Dairy

S he'd always wanted her dream house. Now she had her chance, thanks to a butte with magnificent vistas on the northernmost thirty of the seventy acres that she and husband, Milt, had just purchased from Bill Collier. So, a niche was blasted into the side of the butte, and there Margaret Goldman's dream house was constructed.

The year was 1969 when blasting, grading and construction began. Milt watered the soil continuously for three months to ensure proper compaction, poured concrete into ten-foot holes for support and took particular care to preserve the butte's natural beauty. When completed, the Goldman house majestically overlooked thirty acres of farmland to the east, forty acres of dairy operations to the south and as far as the eye could see in all directions. The northwest view was the exception, extending only as far as South Mountain, although a portion of that annoying view-blocker has since been altered a bit, courtesy of the Arizona Department of Transportation. With a thirty-foot-long living room, two imposing stone fireplaces and a kitchen to accommodate large family gatherings, Margaret's dream had come true.

It was a far cry from the Goldman family's arrival in Arizona from Victoria, Texas, in 1926. At twelve years old, young Milton made the journey in the back of his father's Model T truck. Settling in Tempe on what was left of the Goldman homestead, Milt and his five brothers scratched out a living around their school hours, mostly by farming for others. In the early 1920s Milt's father had owned a half-section (320 acres) of land from Priest Drive clear over to 48th Street, just northeast of today's Arizona Mills Mall. When

the 1929 stock market crash came and he couldn't pay his taxes, he was forced to sell all but 40 acres of his land north of the Western Canal.

To pay his way through Arizona Teachers College (now ASU), Milt rose at 3:00 a.m. seven days a week to milk cows on the former farm of Tempe pioneer Niels Petersen, on which the historic Petersen House Museum on the northwest corner of Priest Drive and Southern Avenue now sits. Goldman swore that he'd never milk another cow after graduating—and he never did, always delegating the task to someone else.

Despite his aversion to milking, son Jim, seventy-four as of this writing, remembered Milt telling him that back in Texas, cotton farmers on one side of town bragged about prices they were getting but lived in shacks, while cattlemen on the other side of town complained about prices they were paying but lived in mansions. "I think I'll stick with the cows," Milt concluded.

In the late 1940s Milt purchased the forty acres adjacent to Priest Drive and the canal. From a humble beginning with 6 cows and some heifer calves in 1950, the Goldman Dairy grew to more than 100 cows by 1952. At its peak, the Goldman herd numbered 450. The family's 2,300-square-foot house, just north of today's Superstition Freeway, "seemed like a mansion" to Jim, compared to the typical 1,200- to 1,500-square-foot farmhouse.

It was in the mid-1960s, during construction of Interstate 10 adjacent to the town of Guadalupe and what would later become Ahwatukee, that the Goldmans first heard of a future freeway that would head east. Representatives from the State of Arizona Highway Department came calling and matter-of-factly advised the family that Interstate 360, the Superstition Freeway, was to be built right through their dairy. The state offered $5,000 per acre for the land but nothing for the dairy business, which state bureaucrats had deemed to be obsolete. The Goldmans obtained fair market value only by taking the State of Arizona and its highway department to court.

During the summer of 1966 Milt Goldman and his son Jim, newly graduated from ASU, met with Bill Collier, owner of the nearly eight-hundred-acre Collier-Evans Ranch. Collier owned all the land on which Lakewood would eventually be built, as well as some acreage on what would eventually become the west side of South 32nd Street. Jim remembered the cantankerous rancher, who died in 1999 at the age of 101, as a tough-talking Texan who didn't mince words but on whose own word one could absolutely rely. "Hard but straight; an honest man," is how Jim characterized Collier. The Goldmans liked the drainage and water access—courtesy of irrigation wells drilled by Collier—on seventy acres

Collier said was "not good for us. It's the poorest piece of ground we've got." Milt purchased their future dairy site for $1,300 per acre.

As Jim recalled, Collier was crystal clear regarding terms of the sale. "I want cash. I don't milk the damn cows," he said, before asking if the Goldmans had a real estate agent (they did not). Ironically, in an area that today is largely shaped by its active realty market, Collier offered that he wanted nothing to do with real estate people. "I hate those S.O.B.s." Further explanation was deemed unnecessary. Five days later the Goldmans owned the land, and in the summer of 1967 the dairy relocated from Tempe to the south side of South Mountain.

One way to access the new Goldman Dairy south of Chandler Boulevard and west of 32nd Street was via a dusty dirt trail on its northern boundary, the eventual Frye Road, and another was on the southern boundary, an unpaved Pecos Road. Feed for the forty-acre operation south of the butte was grown on the thirty acres to the east of it. At its peak, the relocated dairy boasted eight hundred cows. With Milt and Margaret up on the hill, son Jim, who worked alongside Milt running the business, and his brother, Dave, built their own houses side by side on a farm path that ultimately became Glenhaven Drive. The houses remain private residences today.

As seen in 1970, Jim and Margaret Goldman made the right move relocating their dairy to the foothills of South Mountain. *Courtesy Jim Goldman.*

After the sale the Goldmans learned that Collier's son-in-law, Dick Evans—the other half of the Collier-Evans Ranch—had been considering building his own dream house on the butte where Margaret's was eventually constructed. This added a little frostiness to the Evans-Goldman mix, but Jim Goldman advised that Bill Collier gave no indication of Evans's plan during any of their discussions. Regardless, the dairy peacefully coexisted side by side with the Collier-Evans Ranch, and any hard feelings evaporated once the ranch was sold to Charles Keating's Continental Homes in the early 1980s (see page 82).

The Goldmans enjoyed twenty peaceful years at the dairy before developers came calling. Jim Goldman said that the family foresaw the inevitability of streets, houses and neighborhoods and that their philosophy was always the same: "We have no sacred connection to the land like some folks do. Just pay us a fair price and we're gone." Charles Keating's Continental Homes was a potential suitor, but its $48,000-per-acre offer came up short. The Goldmans joint-ventured for a year and sold the majority of their land to Estes Homes, donating 15 acres to the Church of Jesus Christ of Latter-day Saints. Today, that parcel is marked by a house of worship on Frye Road just north of Desert Vista High School. The Goldman Dairy once again relocated in 1987, this time farther south onto 160 acres in Coolidge. Milt officially retired from the dairy business, and he and Margaret remained in her dream house through the 1990s.

The construction of Liberty Lane through the property's lower forty acres displaced the cows, milking machines and other dairy facilities. Today, the former Goldman house looks down on Kyrene's Akimel A-al Middle School and Kyrene de la Estrella Elementary School, which were built where the dairy operation once stood. More recently, the Arizona Department of Transportation demolished several houses in an enclave just north of Pecos Road to clear the land for the Loop 202 Freeway's 24th Street access ramps. In a touch of supreme historical irony, the houses were part of a small neighborhood known as Goldman Ranch.

Once again, the Goldman Dairy was reborn, this time in Coolidge. But history seems destined to repeat itself. Although he'd like nothing more than to continue operating his dairy uninterrupted, in a pattern that's become all too familiar Jim Goldman can foresee a day when the Coolidge operation will have to move or shut down for good. That day might not arrive for another ten or fifteen years, but he'll wait until "houses are on the horizon," almost abutting his land, before considering the next move.

Jim Goldman remains the last link to Tempe's original Goldman Dairy. *Courtesy Jim Goldman.*

And Margaret Goldman's dream house on the hill? Both she and Milt are now deceased, but their former home, under different ownership, still stands. Majestically overlooking Desert Vista High School's athletic fields to the east and the two Kyrene schools to the south, it still offers breathtaking views as far as the eye can see. Standing as a testament to the

Goldman Dairy's legacy and Margaret Goldman's dream, the house marks an agricultural way of life in the future Ahwatukee Foothills that has long since disappeared.

The last word regarding what life at the dairy was like before there was an "Ahwatukee" or a "Foothills" in our village's name comes from Jim Goldman. Reflecting on the serenity of the pre–Ahwatukee Foothills during his family's twenty years there, when the vast stillness was disrupted only by the sound of a distant irrigation pump, the area, he said, was overwhelmingly "quiet."

AHWATUKEE VISIONARY

*H*e wanted to fly, but during World War II the U.S. Army Air Corps was long on pilots and short on bombardiers. He ended up an award-winning pilot as well as a flight instructor. Real estate development followed, and happily for Ahwatukee Foothills, the rest is history.

Although he'd done some light construction work while growing up in Pensacola, Florida, Randall Presley's interest in real estate was sparked by a fellow squadron member. Presley studied for his real estate broker's license while in the service and initiated pursuit of it the day he was discharged in 1946. He began his career with the subdivision of three acres of land and construction of twelve houses in Bakersfield, California, and ended it thirty-eight years later with the sale of his company for $93 million. By then, the Presley Companies had overseen the construction of close to forty thousand homes and been ranked in the top ten in the country by the National Homebuilders Association of America.

Following up on his initial venture, Presley subdivided and developed Bakersfield land in progressively larger parcels, selling more than one hundred houses per year by 1950. His projects became increasingly more ambitious in size and scope until Presley developments dotted both Northern and Southern California. Of his initial expansion into the Southern California market, Presley recalled, "Every morning I'd get up early. I'd start in Oxnard and go all the way down into Orange County. I checked every community, every property and every model home to see what was built

where and what market conditions were." Befitting a master of his craft, he added emphatically, "Because this is what you *have* to know."

A father with three young children, Presley became a widower in 1958. His remarriage three years later to Cecilia (Cee Cee), an Olympic-caliber equestrian rider who had been raised by her grandfather, Hollywood icon Cecil B. DeMille, came after scratch-golfer Presley won the Bakersfield Country Club championship in 1960. The following year he walked away from competitive golf and Cee Cee sharply curtailed her competitive riding as, together, they focused on their marriage.

Business-wise, "I wanted to spread my wings," Presley recalled. "I had been doing work in Bakersfield but wanted to move to a larger arena." By 1969, the Presley Development Company was trading on the New York Stock Exchange and had offices in Chicago, Virginia, New Mexico and Washington, D.C., in addition to California and Arizona. Each office had its own management team, freeing Presley to concentrate on the development of new markets. His companies bought, subdivided and developed the land, subcontracting out the actual construction work. "What you do is set the standards—and make darn sure they're followed!" said Presley. Overseeing projects in multiple states, he gave much of the credit for Ahwatukee's success to Presley Development Company of Arizona presidents Dan Verska and Bruce Gillam.

Starting with that first project in 1946, Presley tapped into a ready-made housing demand by developing on the fringe of an existing neighborhood. Similarly, Presley Development Company of Arizona's initial 1969 venture on one hundred acres of land on the west side of town, Arizona Homes, served as a step-up market for residents of a nearby John Long–built community. The same principle of subdividing land to extend an existing community guided Presley Development's other Arizona ventures, the eighty-acre Parkside Estates, also in the west Valley, and a portion of The Lakes in Tempe. But Ahwatukee broke the mold.

Pilot training brought the twenty-five-year-old Randall Presley to Glendale's Thunderbird Field in 1943. Recalling flight school, he noted that "I always liked Phoenix." Over in California, Presley first learned of 2,080 acres for sale south of South Mountain from a Santa Ana title insurance company in 1970. The location was considered to be quite remote at the time, with the town of Guadalupe and vast swaths of open desert the only things adjacent the relatively new Maricopa Freeway as one headed south from Phoenix. Presley, whose Orange County, California developments typically featured amenities such as roadway medians and lush landscaping,

A widower with three children, Randall Presley remarried in 1961. *Courtesy Pamela Giamarra.*

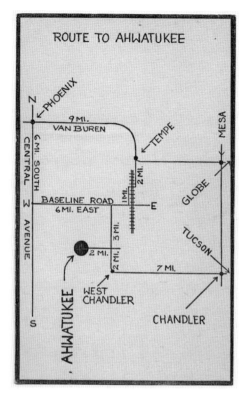

Both Ahwatukee Ranch owner Helen Brinton's 1940s directional map and Presley Development's 1970s version pointed the way to the remote location. *Courtesy Burma Slawson Evans family collection (left); courtesy Robert Peshall (below).*

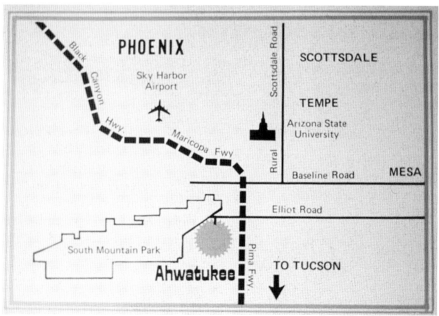

had concerns. "I drove up and down that highway thirty or forty times, asking myself, 'Will people drive past that community on the other side of the freeway and come out here and buy a house? From a buyer's perspective, would I go out there looking?' I finally decided that I would, if there was something that was good enough."

Mindful of the success of Del Webb's Sun City in the far northwest Valley, Presley viewed the future Ahwatukee's freeway frontage, nearby medical facilities and proximity to Arizona State University as positive selling features. He purchased the 1,220 acres that had been the Ahwatukee Ranch land, about a mile and a half west of Interstate 10, from a land syndicate led by ASU professor and land investor John Ratliff; 800 acres to the east were procured from a Phoenix moving and storage firm, Lightning Transfer Company, which had owned the land for decades.

Presley envisioned Foothill Park, the original name of the project, as a golf course retirement community. But due to the size of the acreage, marketing to more than one segment of the housing market made sense. Presley offered retirement living inside a main arterial (Warner-Elliot) loop, family homes outside the loop and light commercial near the freeway. On cotton fields known locally as the Lightning Ranch, Presley Development Company of Arizona broke ground on the future country club golf course in the summer of 1972. Shortly thereafter, seventeen model homes and the Ahwatukee Recreation Center were constructed, both within easy visibility of freeway motorists.

To help attract potential buyers Presley hired a fellow air corps squadron member, singer and entertainer Tennessee Ernie Ford. Ford's radio and print ads got the word out, but since his show business appeal was largely among the silver-haired crowd, the ads reinforced the perception of Ahwatukee as primarily for retirees.

In 1973, resident Jean Grammens and her husband, Lee, did in fact retire to the infant community. Grammens recalled meeting Randall Presley in a hallway at the Ahwatukee Recreation Center shortly thereafter. "Aren't you Presley?," she asked the distinguished-looking gentleman. "I am," he replied. "And who are you my dear lady?" Upon Grammens's introduction, the California developer took her hand, looked her in the eyes and asked softly, "Are you happy here?" When the recent retiree enthusiastically answered in the affirmative, Presley's smile made further words unnecessary. Said Grammens, "He was the nicest man—he was happy that I was happy."

A significant early obstacle involved Ahwatukee's perceived remoteness. "The location wasn't quite ready—I had to bring the people out," Presley

Left: An early Presley sales brochure evokes the minimalistic surroundings during the development's infancy. *Courtesy Pete Meier.*

Below: The Ahwatukee Ranch's gateposts were relocated to the project's South 51st Street entrance to capture the frontier spirit evoked by nearby Fort Ahwatukee. *Courtesy Robert Peshall.*

recalled. "It wasn't adjoining anything, and there wasn't someone right across the street or around the corner. I knew we were going to have to have some kind of attraction to get them out looking. It was a little different." The old twelve-thousand-square-foot ranch house from which Ahwatukee takes its name was considered as a potential historical feature or clubhouse for the eventual Lakes golf course, but its deteriorated condition made refurbishing unfeasible.

To help create interest, Randall Presley conceived of something so different that it not only put Ahwatukee on the map once and for all, but it also generated media coverage from as far away as Australia, Germany and Japan. His idea of a futuristic house that could accommodate large numbers of the touring public was turned into a reality by Scottsdale's Frank Lloyd Wright Foundation. Open for tours in 1980, Ahwatukee's House of the Future attracted some 250,000 people to the area over the next four years, driven via tour buses past the various model homes through the community. As the economy's late 1970s malaise lifted, sales took off. At its peak in 1984, Ahwatukee houses were selling at the rate of more than one per day.

An additional 640 acres landlocked at the base of South Mountain were later developed. Originally conceived as an equestrian section, demand was

The House of the Future, the beneficiary of more than $1 million in donated components and services, is shown here under construction in 1978. *Courtesy Charles Schiffner.*

Opened for public tours from 1980 to 1984, the House of the Future as viewed looking south, helped spark demand in Ahwatukee's Custom Estates section. *Courtesy Charles Schiffner.*

lukewarm among the horsey set, many of whom wanted multi-acre lots. But among upscale homebuilders demand was red hot, and for a while, building lots were sold by lottery.

In appearance, vitality and enthusiasm, the grandfather of eight and great-grandfather of ten presented the image of a man twenty years younger. When he sold his company to Pacific Lighting Corporation in 1984, "I had been doing it for thirty-eight years and I was done," he emphatically recalled. Done with development, perhaps, but he was ratcheting up involvement in his most passionate pursuit, oil and gas exploration. From his Newport Beach office Presley oversaw Presley Petroleum, a company he started with the drilling of its first well in 1951. It continued with explorations in Oklahoma and Kansas. "We're more involved and have more deals than ever," the self-described "semi-retired" Presley said with a laugh in 2005, showing no signs of slowing down even before his 2012 death at age ninety-three.

Ahwatukee was both the largest and the riskiest development project of Randall Presley's career. "You're breaking open a whole new area of land.

No one had gone close to South Mountain, which was kind of a dividing point [with the city of Phoenix]. We didn't have utilities and had to go on a little bit of faith that we could get those things," he recalled. But by the time the other master-planned communities that comprise today's Village of Ahwatukee Foothills were built, the area was no longer considered to be remote. Rather, it was viewed as a highly desirable place to live, thanks to Ahwatukee having paved the way.

Randall Presley's development of the first master-planned community on the south side of South Mountain stands as a monumental achievement that ushered in an era of unprecedented growth in the southeast Valley. In creating Ahwatukee, he permanently changed the face of both the Phoenix and southeast Valley landscapes and left us with his legacy of vision combined with risk and reward.

A Pre-Lakewood Visit

One grandfather was chased into Arizona at gunpoint in 1887. The other was an early homesteader whose surname graces Scottsdale's Hayden Road. Growing up, his family's Bloody Basin ranch encompassed three townships, with each township covering thirty-six square miles. He was Richard Evans, for thirty-five years one half of the Collier-Evans Ranch. Today, we know the ranch site as the master-planned community of Lakewood, which offers only a few reminders of the peaceful rural setting that preceded it.

The genesis of the ranch lies with Bill Collier, a Texas transplant in 1917. Collier washed windows at Chandler's San Marcos Resort before eventually purchasing a section of land (640 acres) on the south side of West Chandler Road—later Williams Field Road and now East Chandler Boulevard—between today's 32nd and 40th Streets in the late 1930s. Later, another 130 acres north and west of today's Desert Vista High School rounded out the property. Collier paid forty dollars per acre, a steep price for the rugged, raw desert land on which decomposed granite and sandy "soil" made farming a visionary concept.

In his youth Evans had been a cowboy on his family's ranch. After his 1948 discharge from the U.S. Navy he married Bill Collier's daughter, Helen, and the following year joined Collier on the Collier-Evans Ranch. A ranch in name only, the farm grew primarily cotton, barley and wheat. The Beldens, owners of Pima Ranch and the eventual Mountain Park Ranch, and local farmers Arthur Hunter and Eli and Bill Gates were neighbors. While today a

cup of Grey Poupon might be borrowed by Lakewood neighbors, "I bought a horse off of him" is how Evans summarized his relationship with Byron Slawson, caretaker of the Ahwatukee Ranch. Its owner, midwesterner Helen Brinton, was always well dressed and "a little out of our style," he laughed.

Water put the "Lake" in Lakewood, but the Highline Canal, lifeblood of area farmers, ended at 40th Street, right where the ranch property began. Collier's land carried no water rights in the late 1930s, and five wells had to be drilled. Of those original wells Evans said, "The ones higher up, closer to the [South] mountain, eventually went dry. So the wells we ended up with were right down by the Indian reservation." Because the land dropped twenty-five feet from north to south, the water had to be pumped uphill to irrigate. The remnants of a neighbor's well, on International Harvester's former Phoenix Proving Grounds, was visible for years on Pecos Road near 24th Street.

"When they [Bill Collier and his brother, Faye] cleared the land they killed hundreds and hundreds of rattlesnakes," said Evans. But some survived, the father of five and former Kyrene School Board member matter-of-factly recalled. "The little girls [Evans's daughters] were riding their tricycles around the house and there was a rattlesnake coiled in the flower garden a few feet away. They rode right past it several times. They didn't know it was there and neither did we until later." On another occasion, "The wife [Helen] went out after dark to hang some clothes on the line and heard this snake rattle behind the house. So I got a flashlight and went out, and he was underneath a water softener behind the house. I said, 'Hold the light and I'll drag him out.' Well, when I pulled him out she screamed, ran off and left me in the dark with the snake," laughed Evans. Both he and his wife died in 2017, a year before their seventieth wedding anniversary.

In 1955, Bill Collier financed Evans's purchase of forty acres on the northeast corner of South 48th Street and Chandler Boulevard. In contrast to their ranch, the acreage had water rights to the nearby Highline Canal. Evans's son, Rick, grew cotton, corn and, for a while, Eldarica pines (Christmas trees) on the property.

International Harvester's proving grounds was the ranch's only westerly neighbor. But three was a crowd in 1967 when Superstition Freeway construction displaced dairyman Milt Goldman. He promptly bought seventy acres of Collier-Evans land on the west side of 32nd Street for his relocated dairy, where today two Kyrene schools sit on Liberty Lane.

Was it noisy having the proving grounds as a next-door neighbor? "No, they were a half mile or more back on the property so we didn't hear

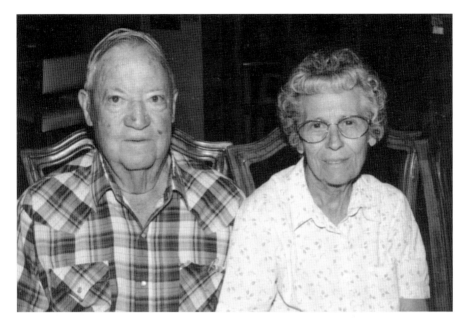

The occasional snake didn't rattle Helen and Richard Evans, one half of the Collier-Evans Ranch, pictured here in 2005. *Courtesy Evans family.*

anything," said Evans. "They had a farm division, and me being a farmer, I could get test equipment to run on the farm. If they had something available I could use it for nothing. I got mostly tractors, discs and plows. If it was a rush project, they'd want the thing to run twenty-four hours a day, and they'd even furnish the fuel. I had a good rapport with them. They were nice to me."

Spurred by Mesa's Williams Air Force Base, Williams Field Road was paved during World War II all the way to its 32nd Street end for the benefit of tank testing at the then Phoenix Proving Grounds. That simplified local college student and present-day philanthropist Ira Fulton's job, delivering the *Arizona Republic* to the Collier and Evans households on his newspaper route. In keeping with Ahwatukee-to-be's 1971 "Tempe property" designation, Fulton's delivery to the Collier-Evans Ranch occurred at Rural Delivery 2 in Tempe, Arizona.

Salt River Project constructed its high-tension power lines from the Palo Verde nuclear facility in 1983. Evans recalled, "I fought that thing tooth and nail. The Indians wouldn't allow it, and I thought we had it stopped over on the west end of South Mountain. They [SRP] had to cross the park,

which the City of Phoenix wouldn't allow. I tried to get them to go across the proving grounds and then hit the end of the Kyrene ditch—the Highline Canal—where they'd have a right-of-way. Finally, they threatened to sue us and take the property by condemnation." In the end, following the Gila River Community border and in the process turning a dusty old farm road into Pecos Road, Evans negotiated a $320,000 payment from Salt River Project in exchange for a one-and-a-half-mile-long strip easement at the southern edge of the ranch.

Evans laughed recalling Randall Presley's initial development of Ahwatukee in the early 1970s. "At first we thought it was Elvis Presley [who was actually Randall's distant cousin]. But that's when they [prospective developers] started working on us." By the early 1980s, "We knew we had to get out. Prices stayed the same as costs skyrocketed. It was costing us $22,000 a month to power the wells." Would-be developers performed due diligence: "They tested our wells and said, 'You can't drink that water!' Several outfits thought they would like to buy but didn't have the money."

"We had decided that we weren't going to sell for anything but cash—no terms or anything like that," said Evans. LeRoy Smith, he of the Pima Ranch property (see page 135), proposed trading land that he owned in Chandler's future Ocotillo for the Collier-Evans Ranch. Finally, in 1984, "Keating came out and wrote us one big check," Evans recalled. That would be Charles Keating of Continental Homes, who had recently sold his half-interest in Continental's Mountain Park Ranch joint venture with Genstar.

By then Evans was overseeing day-to-day operation of the ranch, with the now eighty-six-year-old Bill Collier several years removed from running the business. When Continental Homes' check was delivered Evans advised that, "he [Collier] wants to see money in his hand! They went back and brought $2,000 in bills and laid it out on the coffee table. Bill was more excited to see those bundles of cash than he was about the big check!" said Evans of Collier, who died in 1999 at the age of 101.

To make Lakewood feasible, Evans said that "Keating had to develop water somewhere else in exchange for city water. I think he went up on the Verde River and drilled wells and gave those wells to the city in order for him to have water on this project." Keating, a collegiate swimmer and developer of Mesa's aquatic Dobson Ranch and The Lakes in Tempe, made digging two signature lakes on the former Collier-Evans property his first order of business.

Mike Longstreth, the original Mountain Park Ranch project manager who brokered the sale of the Collier-Evans Ranch, offered his perspective:

Bill Collier, who lived to be 101, was headed to the local cotton gin in the late 1960s. *Courtesy Evans family.*

"At that time in the homebuilding game lakes had proven to be a really good asset [citing Mesa's Dobson Ranch as an example]. The common vehicle to use was a golf course—but that was so common that it didn't distinguish itself. And so the fact is that water, being both precious and beautiful, became something that would really punch out Continental's master-planned community—which it did!"

A provision of the sale allowed the elderly Bill Collier to remain in his house in a life-estate agreement. Evans and his wife lived for a year across Chandler Boulevard in a Mountain Park Ranch Continental Homes house offered up by Keating. A full year passed before "about fifty earthmovers," recalled Evans, appeared and began digging out the fifty-two-total-acre lakes, with dirt piling up nearby the Collier house. It was time to move on.

Evans subsequently paid one-sixteenth of Lakewood's purchase price to acquire acreage in Gilbert at $19,000 per acre, where he constructed a fourteen-acre, seven-house family compound in 1986. Fittingly, the compound sits on Evans Way. That land on the northeast corner of South 48th Street and

With Charles Keating's two signature lakes dug, Bill Collier's house (*top*) was the only remnant of the Collier-Evans Ranch in 1985. *Courtesy Evans family.*

Chandler Boulevard? When the forty-acre property was sold to commercial developer Vestar in 1997, it was priced at $4.50 per square foot.

A bit of Lakewood trivia involves the filming of the movie *Mikey*, which was released in 1992. Filmed primarily in Lakewood near 37th Street off Lakewood Circle, longtime Lakewood resident Mike Schmitt—he of the leading parade-boss role in the village's annual Easter Parade—recalled receiving a flyer warning of a loud noise to occur on a particular day and time in late 1990. Lakewood's peaceful silence was shattered as a half-scale house that had been built across the lake was demolished on cue. The scene lives on in perpetuity near the end of an otherwise utterly forgettable feature film.

In 2005 the eighty-one-year-old Richard Evans, grandfather of twenty-one and great-grandfather of seven, offered, "Looking back at Arizona and the Valley, we've ruined one of the richest agricultural areas in the country. Lots of produce used to be grown here, and we've lost all of that. It just seems a shame that all of this beautiful ground is gone under cement. But it's forward motion, I guess."

As a final perspective, Evans espoused old-fashioned self-reliance: "The generations now have me worried. There doesn't seem to be as much common sense. You buy something and the instructions are like you were a

little child. Back in my time and in older generations, my kids had to help on the farm. They'd get some basic knowledge that a person would need in life. You didn't have anybody to fix things for you, so you'd fix them yourself. The kids are not getting that anymore."

Meanwhile, the Collier-Evans Ranch lives on. On a wall in Lakewood's Kyrene de las Lagos Elementary School's library, the farm's crops remain forever green, set serenely against a brilliant blue sky and the backdrop of South Mountain. It's a painting by Evans's daughter, Robin, that recalls agriculture as a way of life in a time long gone. Reflecting on the selling of his land, and in a nod to Lakewood, Evans allowed that "maybe we made a lot of people happy down there."

FROM A RAG TO RICHES

Read all about it! A single headline in a sleepy, once-a-month eight-page newspaper changed the course of Ahwatukee journalistic history and led to the creation of the periodical that graces twenty-eight thousand village driveways weekly. More to come!

But first, some perspective. When Mack and Ellie Roach became Ahwatukee's very first homeowners, it was newsworthy. When construction started on a clubhouse for the area's only golf course, it was of interest to the relatively few people living here. And when yet another gala potluck dinner was being planned, well, everyone (as it were) wanted to know about it. The year was 1973, and that December marked Presley Development Company of Arizona's launch of a one-page double-sided monthly community flyer called, of all things, the *Ahwatukee News*.

The term "newspaper" would have been accurate, as the flyer did contain community news and was printed on a piece of paper. What began as a double-sided promotional sheet read by the handful of pioneering residents evolved into the weekly newspaper that serves today's Village of Ahwatukee Foothills. From the original *Ahwatukee News*, when the reference was to a tiny development of fewer than two hundred houses, to today's *Ahwatukee Foothills News* serving a population approaching ninety thousand, the written word in our village has come a long way in tandem with the community.

Presley launched its monthly flyer to help generate interest in the minute development, as well as to foster a sense of community among the handful of

VOLUME 1
NO. 1

DECEMBER
1973

The Ahwatukee News

CLUBHOUSE AND PRO SHOP NOW UNDER CONSTRUCTION

Work is well started on the spacious clubhouse for our beautiful 18-hole championship golf course. Dick Mulhern, project director of the Ahwatukee community, says May 1st is the scheduled completion date.

As you will see, the building will blend with the territorial character of our Retirement Recreation Center. It's a split level with mansard roof and stucco exterior.

There will be over 3,000 square feet of lounge area-- a snack bar, liquor bar, and a comfortable conversation pit by a wood-burning fireplace. The design provides for expanded dining-room facilities and a complete kitchen.

Members will also use the men's card room, locker room, showers, etc. The ladies will have comparable facilities. The pro shop will have ample room for equipment display in a 1,000 sq. ft. space. Underneath the pro shop there will be golf-cart storage and maintenance.

(Continued on page 2)

MACK AND ELLY ROACH ARE OUR FIRST FAMILY

Say hello to the nice couple who live at 5010 Magic Stone Drive. They were the first to move in to a new home in Ahwatukee just before October.

Mack (not Mark) has been general manager of a Phoenix roofing company for many years. He graduated from Texas A & M, loves golf, and plays with a 15 handicap.

Wife Eleanor was a Toronto girl. She and Mack have been happily married for 26 years. Elly, too, is a most enthusiastic golfer and looks forward to breaking 100. How handy that their lovely home is right on the 13th fairway!

A married daughter lives in California. Another daughter is a freshman at ASU. But George lives at home. George is a large homespun sort of canine who exhibits all the superior characteristics of a pure-bred Siberian "moose-hound".

(Continued on page 2)

TOWNHOUSES SLATED FOR EARLY SPRING OCCUPANCY

The first 10 duplex townhouses are now being erected in Section RD-1 which is to the west of the Retirement Recreation Center. These are grouped as five pairs and are reserved for retirees. Work started December 1st.

An additional 48 townhouses will be started the middle of December in Section T-1 to the east of FS-1. Half of this group will be for families, and the other half of these T-1 townhouses will be for adults.

AHWATUKEE SALES STAFF (l to r): Al Greenberg, Dan Heaton, Bruce Walters, Dick Patches, Tom Randolph (V. P. Sales) and Pete Meier.

RETIREMENT RECREATION CENTER IS READY FOR ACTION

Most of the visitors to Ahwatukee have had a "sneak preview" of this tremendous facility which will be open and operating in the very immediate future when a director of activities has been selected. (Plans are also in progress for the Family Community Center which will be located south of the golf course).

The Retirement Recreation Center has an impressively spacious Grand Hall for dances, dinners and speaker meetings. It measures 4,000 square feet. There is a large stage at one end, and an adjacent kitchen. At the other end of the hall there are 3 lighted billiard tables and a comfortable men's lounge with poker tables.

Separate rooms have been assigned for arts and crafts, sewing, ladies' card games, and shops for lapidary and woodworking. There is also a well-equipped exercise room, a jacuzzi room, and men and women's locker and shower facilities, saunas, etc.

(Continued on page 2)

December 1973's first issue of the double-sided flyer contained all the news about what was happening in Presley Development of Arizona's brand-new community. *Submitted image.*

its first residents. During periods of especially slow home sales—er, news— the one-page flyer encompassed two months at a time. The news of the day reflected the simple pace of life that attracted many retirees here during Ahwatukee's infancy. "Say hello to the nice couple who live at…" read the

opening sentence in that first issue, announcing that Ellie and Mack Roach were couple number one. "Fire Hydrants, Mail Delivery and Area Street Lights Coming" blared—make that *whispered*—a headline in the January 1974 edition. Still "Another Pot-Luck Dinner" was prominently featured on page one a few months later. Of course, all it took for a reader to navigate from the first page to the last was one flip of the wrist.

As the small community slowly grew, Presley's promotional flyer was replaced by Ahwatukee's first actual newspaper, the *Ahwatukee Sentinel*. So named because of the imposing presence of the stockade-like, construction-equipment storage compound, Fort Ahwatukee, on the former western edge of the development, the monthly eight-page paper was produced by a Mesa publisher "for Presley of Arizona and the residents of Ahwatukee" and debuted in October 1976. The newspaper was edited by a recent Nebraska transplant named Clay Schad. It provided more in-depth coverage of similar small-town community happenings, announcements and news and, in retrospect, serves as a time capsule of those early days. Advising that "there is no official word yet as to the opening of the new school," referring to Kyrene

Presley's flyer was replaced by an eight-page monthly newspaper carrying a name reflective of the stockade-like Fort Ahwatukee on the community's western border. *Courtesy Clay Schad.*

de las Lomas, and reporting that "authorization has been given…to begin work on construction drawings for Mountain View Lutheran Church," the *Sentinel*'s second edition reported on what were to become, respectively, the first school and church ever in the future village of Ahwatukee Foothills.

A University of Nebraska journalism major who arrived in the Valley in 1976, Schad cut his teeth editing the east Valley's *Mobile Messenger*, a mobile-home periodical. Since that was done part time Schad also worked as an independent contractor for Presley Development of Arizona. The latter job involved attending Wednesday morning staff meetings to gather newsworthy items and then taking photos and writing stories and press releases that he distributed to major newspapers in and around the Phoenix area. A typical bit of "news" would involve Presley's opening of a new subdivision or its next area of land opening for development.

That single headline referenced earlier? Bruce Gillam, president of Presley of Arizona, took umbrage at a front-page *Sentinel* story referencing a Las Lomas fundraising effort in May 1978. Innocently enough, the newspaper reported that folks could own a square yard of schoolyard dirt with a deed in one's name in exchange for their purchase of it as part of a fundraiser for school landscaping. In a classic it's-not-what-you-say-but-how-you-say-it moment, the headline leapt from the page as Gillam's eyes widened: "Cheap Land for Sale in Ahwatukee."

Schad, who had no involvement with the offensive headline, was immediately summoned to Gillam's office. The president's hands were shaking at the sight of the headline's "C" word—a word that he did not want in any way to be associated with the community—when he asked how soon Schad could begin putting out his own newspaper. "If you're telling me right now, then I can have one ready for you next month," replied Schad. Said Gillam, "Do it." Schad sought clarification: "I'm a little unclear, Bruce. Who exactly is going to own the paper? Who's going to send out the bills? Who's going to sell the ads? Who's going to pay the print bill? Who's going to keep what's left over?" Gilliam's response was, "Clay, take the ball and run with it."

And thus the *Ahwatukee News* was born. Or was it reborn? July 1978's volume 1, number 1 consisted of four pages, with Schad serving as writer, photographer, ad salesman and delivery driver. With a typewriter on his kitchen table and access to the pay-as-you-go *Tempe Daily News* typesetting facilities, Schad created the newspaper's layout and oversaw its monthly distribution of 2,000 copies within the still-tiny community; 800 issues were more than sufficient for each home in the fledgling hamlet, as there *were* no businesses save for the Ahwatukee Insurance Agency being run from the owner's house and a lone Circle K on Elliot Road—the remaining 1,200 issues were distributed across the freeway, where all of the advertisers were.

One word in a *Sentinel* headline sparked the end of the newspaper and President Bruce Gillam's fateful words to Clay Schad. *Courtesy* Ahwatukee Foothills News.

From the late 1970s through the early 1990s, coverage once again reflected the Mayberry-like feel of early Ahwatukee. New store openings, the country club's golf and tennis tournaments and announcements of new phases of development dominated the feel-good tenor of the times. In contrast to today's hot topics, one of the few controversial subjects back then involved Ahwatukee's long-tortured path toward annexation, which remained front-page news for much of the 1980s (see page 126).

The free-of-charge *Ahwatukee News* was not without competition. Ron Lane, Mountain Park Ranch project manager, recalled, "The only problem I had in overseeing things was with the *Ahwatukee News*. I told them, 'You're sending the paper to Mountain Park Ranch; how can you call it the *Ahwatukee News*?' They were very adamant that they weren't going to change it. Some press guys came after me—something about limiting free speech. So I just moved on." Shortly thereafter a few readers in that enclave, full of civic pride in their new development, bristled at the name of the older "Ahwatukee" defacing the front page of the future village's community periodical. In 1987 the *Mountain Park Ranch Record* arrived on the scene, distributed free to residents of that fledgling master-planned community. A decade later, the *Mountain View Community News* appeared. In

A strong community supporter, Clay Schad receives an award from Kyrene de las Lomas Elementary School principal Dixie Shirley in 1989. *Courtesy* Ahwatukee Foothills News.

response, Schad changed his newspaper's banner, strategically rearranged a few stories and, simple as that, Mountain Park Ranch and then Lakewood had their own versions of the periodical.

The newspaper assumed its current name when the City of Phoenix officially christened the community the Village of Ahwatukee Foothills in 1991. That coincided with the year in which Schad's older brother, Randy, the periodical's advertising manager, died suddenly at the age of forty-one. Four years later a startup with the banner *Ahwatukee Foothills Sun Times* published every other Sunday with an ambitious press-run of twenty thousand. The absence of sufficient advertising revenue did in all competitors within a few years of their debuts.

After twenty years at the newspaper's helm, the Nebraska journalism major sold the *Ahwatukee Foothills News* to the *Arizona Tribune* in 1998. From his 1976 arrival with little more than a journalism degree and limitless enthusiasm for a new community, Schad parlayed his kitchen table venture into a $3.5 million sale.

With its humble beginnings of once a month, then bimonthly, to the *Ahwatukee Weekly News* in late 1988, its biweekly format in the mid-1990s and, finally, back to a weekly publication under the leadership of Executive

Editor Paul Maryniak, the newspaper marked its fortieth anniversary in July 2018. At first tiny and charmingly naïve—much like Ahwatukee itself—the printed word has grown, matured and mirrored the evolution of the village with which it grew up. Today's coverage reflects a markedly different world than that of 1973, yet the newspaper in your driveway and on your screen is but the latest chapter in a story that began over four decades ago, with a friendly request to "Say hello."

THE ROADS LESS TRAVELED

*O*riginating in mainstream east Valley cities and towns, they were mere afterthoughts as they continued west, heading toward the future Ahwatukee Foothills. They may have been main thoroughfares in the areas where they originated, but for the most part, their westerly routes dustily meandered toward South Mountain before petering out near its foothills.

They were the roads and byways of the Kyrene farming community, carved out of the dry East Valley's desert canvass in the first few decades of the twentieth century. Long before there was an Ahwatukee Foothills and longer still before there was Streets of New York, the land on which today's village stands could be accessed primarily by rugged remnants of east Valley farm roads. For a few pioneering farmers who arrived early enough, the eponymous farm road that fronted their homestead by default took their names, as evidenced by Hunter Drive and Elliot and Warner Roads.

President Lincoln's 1862 Homestead Act helped open the West to settlement. In exchange for living on and farming open federal land, typically in 160-acre parcels, Arizona's hardy pioneers were granted ownership of the tracts on which they staked their claims. Among the streetwise, two of the more well-known homesteaders were Reginald Elliott and Samuel Warner.

Arriving in the Arizona Territory in 1908, the Kansas-born Warner homesteaded on 160 acres at the southeast corner of today's Priest Drive and Warner Road, site of the present-day Warner Business Center. Upon the 1921 construction of Casa de Sueños (the area's first winter residence,

later to be renamed the Ahwatukee Ranch), the narrow dirt road was utilized all the way into present-day Ahwatukee. In effect, Warner Road's two straight-as-an-arrow westernmost miles served as a driveway that dead-ended at the ranch house's garage. The "driveway" was reconfigured shortly after Ahwatukee development commenced in 1972, graded in a gentle curve to become one-half of the Warner-Elliot Loop.

In 1914 California native Reginald Elliott settled on 160 acres on the southwest corner of *his* farm road and the present-day Priest Drive, current site of Tempe's Costco Plaza. The discrepancy between Elliott's surname and that of Elliot Road? For the Arizona Department of Transportation's 1970s sign makers, good help was hard to find and no do-overs were allowed: the homesteader's name was misspelled and it—minus the second *t*—stuck.

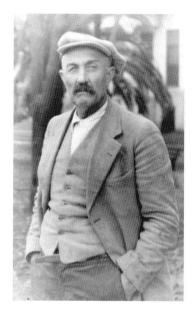

With a look reflecting his hardscrabble homesteader's life, Samuel Warner was the first of several generations of Kyrene farmers. *Courtesy Owens family.*

Arthur Hunter began clearing land and farming in the future Ahwatukee Foothills area in 1908, coinciding with Samuel Warner's arrival. Hunter's 160-acre homestead between present-day Thistle Landing and Chandler Boulevard ran along a dirt country lane that for fifty years appeared on area maps as Hunter Drive. When Ahwatukee's first phase of development commenced its western border was temporarily defined by a section of soon-to-be-paved South 48th Street connecting Elliot and Warner Roads. Development eventually extended south, and today, the bustling north–south artery bears little resemblance to bucolic Hunter Drive and its rural-desert surroundings. The march of progress widened, renamed and paved over this long-forgotten road, consigning it to Ahwatukee Foothills history.

Five-year-old Milton Ray's father moved his family from his native Mexico to Chandler and began farming eighty acres between today's Cooper and Gilbert roads in 1915. Upon the patriarch's death five years later young Milton helped to take the reins of the family's farming operation. A 1929 graduate of Chandler High School, Milton spent his life farming in Chandler until buying the farm himself in 2000, at the age of ninety.

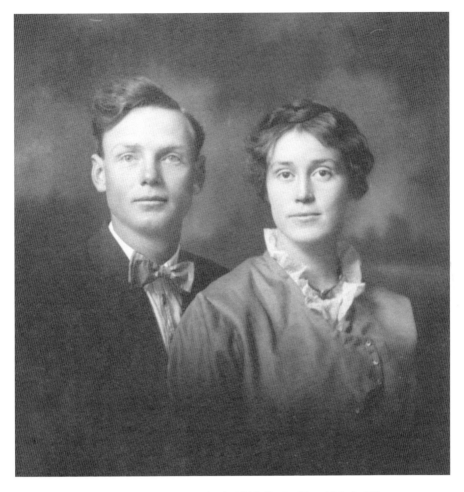

Arriving in the Kyrene farming community in 1914, Reginald and Marie Elliot homesteaded on the site of today's Costco outlet. *Courtesy Owens family.*

Farther west and decades before the term "interstate highway" became a part of the lexicon, a dusty east–west trail named Pima Road aligned with Ray Road as it dead-ended a quarter mile west of today's South 48th Street at the Pima Ranch buildings. These were all that remained of New Yorker William Belden's 1929 planned construction of a grand winter residence on the land now known as Mountain Park Ranch. Named for Arizona farmers' early twentieth-century cash crop, pima cotton, the *P* word became so ubiquitous that a rechristening of several Pima roads around the state occurred. Thus, Pima Road became Ray Road in the late 1930s, although it

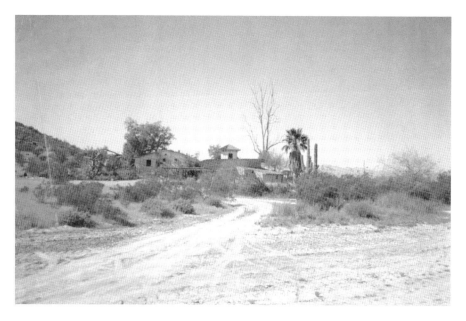

A road to nowhere is the dusty Ray Road as it dead-ends at the Pima Ranch outbuildings in 1983. *Submitted photo.*

remained a nondescript, dusty and desolate dead-end until the development of Mountain Park Ranch fifty years later. Its most notable feature during that half century? The Gates dairy and junkyard, on the southeast corner of the intersection near today's South 48th Street.

A mile south and ten miles east of the future Mountain Park Ranch, Mesa's Cleveland Avenue honored our only two-separate-term president. It was renamed West Chandler Road in honor of not a farmer but a veterinarian, Dr. Alexander Chandler, founder in 1912 of the city that bears his name. With the onset of World War II the construction of Mesa's Higley Field, soon to be called Williams Field, commenced, with early Arizona aviator First Lieutenant Charles Williams as its namesake. Dr. Chandler's naming rights didn't last long, as the boulevard was rechristened Williams Field Road. The multiple name changes marked the site's growing into the U.S. Air Force's largest pilot-training facility in the country, and the field became Williams Air Force Base in 1948. Today, we know it as Phoenix-Mesa Gateway Airport.

Of the east–west streets in present-day Ahwatukee Foothills, only Williams Field Road stretched as far as South 32nd Street some seventy-odd years ago. Beneficiary of air base–related government funding, the artery was widened

and paved during the war in part to accommodate the military trucks and heavy equipment traversing it on their journey to and from the Phoenix Proving Grounds. Thus, it is the one exception to the dirt-and-dust condition of other pre-Ahwatukee roads.

The thoroughfare's South 32nd Street termination marked the beginning of a private dirt road that led to the future Phoenix Proving Grounds, a U.S. Army tank testing area during World War II. Ideally situated due to its distance from civilization—as well as its similarity to the hot, dusty conditions encountered in U.S.-engaged West Africa—thousands of pre-Foothills acres were used for tank testing by the U.S government during the war. Beginning in 1946, International Harvester Corporation began leasing the land, and the Proving Grounds was established, occupying the entire future Foothills and Club West for close to the next forty years.

Today, The Foothills' main roads follow almost exactly the route of Harvester's main test tracks. Not until development of Mountain Park Ranch began in the early 1980s was Williams Field Road pushed west beyond South 32nd Street, curving to connect with a newly extended, looping and paved Ray Road. Its back-to-the-future reincarnation, this time as *East* Chandler Boulevard (go figure), occurred in 1988.

Although rapidly becoming a footnote to history, Pecos Valley Alfalfa Milling Company Road was pushing the envelope a bit in the simpler-is-better street name category. So it is that the pre–South Mountain Loop 202 freeway at the southernmost border of today's village was known by the more concise and street sign–friendly Pecos Road. Named after a 1935-era enterprise that ground hay for use in livestock feed, the mill and its feedlot were located between today's Arizona Avenue and McQueen Road. Similar to the Kyrene farming community's Ray Road, the western section of a sparsely traveled dirt road came to be called Pecos Road due to its geographical alignment with the mill to the east. Continuous evolution has it now completely reconfigured as a freeway.

These reincarnated pre–World War II roadways ferry us around today's Village. To paraphrase poet Robert Frost, "Two roads diverged at an intersection and I took the one leading to Ahwatukee Foothills....And that has made all the difference."

Scarring, Development and Serenity

eneral Motors' U.S. Army tank testing facility; International Harvester Company's heavy equipment proving grounds; and the largest land transaction in Phoenix history to that time. Where does the story of The Foothills begin?

It seems like such a sure thing today, but it wasn't all that long ago that The Foothills was being contemplated for development over some of the most battle-scarred terrain within the city of Phoenix.

Following Burns International Corporation's January 1984 purchase of the 4,140 acres that had been International Harvester's Proving Grounds, the *Arizona Republic* heralded the prospective new development: "12,000-Home Project Planned," adding "golf courses, hotel to serve community close to Ahwatukee." Burns spent the first two years investing in infrastructure improvements before entering into a joint-venture partnership with Del Webb Corporation in 1986. Originally marketed by International Harvester Company as Pecos Ranch, a series of surveys and interviews done by the joint venture resulted in the name The Foothills at South Mountain being chosen for the master-planned community. Like Mountain Park Ranch before it, The Foothills became the largest master-planned community in City of Phoenix history until it sold Phase III of the property in 1988.

Jack Gleason arrived as the project's general manager in May 1988. A Del Webb employee who reported to the partnership, Gleason was a construction industry veteran who had most recently managed the development of

another upscale master-planned community, Phoenix's Tatum Ranch. He had seen International Harvester's dirt roads in his role as a competitor of The Foothills, but by the time Gleason arrived, some paving had been done and a few homeowners had moved into the first developments of Canyon Springs and Cabrillo Canyon.

Said Gleason, "As a competitor, I had looked at the Foothills with a lot of envy because they had put so much money into the front end, developing the infrastructure." Individual builders were able to purchase lots and immediately start building on them. The joint venture survived a very depressed early 1990s real estate market through the use of "rolling options," wherein the partnership financed builders who bought a limited number of lots at a preset price. If the builder defaulted, the partnership kept the substantial deposit.

Today's land combining neighborhood amenities with beautiful mountainous topography had been slated for development by the mid-1980s. When joint venture 4140 Partners (in a nod to the land's acreage), aka Burns International Inc. and Del Webb Corporation, sold its first parcel of land to the Arizona Department of Transportation, the transformation from badly scarred desert to marketable master-planned community was underway. The spring 1987 sale of a five-hundred-foot-wide, several-mile-long strip just north of Pecos Road gave some indication of where a future freeway's southern boundary would be. ADOT designated the strip as a clean-take area, which meant that The Foothills' southern border might someday contain a freeway—eventually.

Gleason has always been amazed that the purchase was made that far in advance but understands the concept of buying land while it is relatively inexpensive. He said, "As people would move into the Foothills, there was a huge uproar when the state started putting it [the clean-take area] on maps. 'Oh my God, it really is here!'" Merits of the Loop 202 aside, "Absolutely no one should be surprised," Gleason said in 2009, years before freeway construction started.

Initially the property had been divided into three chronological development phases. The first included the land between 24th Street and Desert Foothills Parkway, on which the Foothills Golf Club lies today, with Phase II immediately west of that. Groundbreaking occurred in June 1986, and the first homeowners moved into the UDC-built Canyon Homes subdivision in July 1988. Four months later UDC purchased the entire one thousand acres slated as Phase III on the westernmost part of the project, which it developed as Club West. The sale enabled the partnership to pay

off a substantial portion of its debt, something that was very attractive at a time of high interest rates.

From the beginning, Gleason said, "The biggest issue was always 'How do we get enough people to come around the mountain and find us?'" Marketing Director Ann Glover provided a good answer in 1986 by starting what would become an eagerly anticipated annual tradition. She put up some Christmas lights. With strands of white lights illuminating trees and cacti on a portion of Clubhouse Drive, the relatively modest marketing display did the trick. "It was brilliant—literally!" remembered the former general manager, whose first few summers on the project were marked by hostesses in the Foothills Information and Sales Center (today's golf course clubhouse) beginning the Herculean task of untangling hundreds of light cords each July.

Limited accessibility was another challenge in the early days. Years before groundbreaking occurred in July 1986, Mountain Park Ranch project manager Frank Pankratz oversaw initial infrastructure of Mountain Park Ranch. He did all he could to limit the ease of entry into the proving grounds and, as such, into the future Foothills. "It was a hard left or a hard right that you'd have to take," recalled Gleason. "It was easy to miss. It would not be a logical turn unless you knew where you were going." Ironically, when Pankratz was hired on as The Foothills' first general manager (Gleason's predecessor), he inherited the road configuration as the entrance to his project. The City of Phoenix got involved, as did the adjoining master-planned community, resulting in the intersection of Chandler Boulevard and Ray Road as we know it today. Said Gleason, "It [Chandler Boulevard] totally gives the Foothills its charm. It makes it more unique and tells you that you're going someplace that's a little more upscale."

Now retired, Gleason reflected, "I'm proud to have been a part of what created a nice lifestyle for people and families, and which hopefully allows families to strengthen and grow. The hope was to deliver more than just a subdivision—to give people a community, one that they're proud of and one that allows the family unit to endure."

Tom Kirk succeeded Gleason as The Foothills general manager in 1990. Kirk was a Del Webb employee who had arrived on the project six months after its 1986 groundbreaking. Kirk's predecessors had launched the project and charted its initial course, and Kirk oversaw implementation and adaptation of plans that were largely in place.

As in the original Ahwatukee, golf courses were a natural starting point. Considered the hallmark of any self-respecting master-planned

Tom Kirk spent seven years at the Foothills, the last three as general manager overseeing the project. *Courtesy Camelot Homes.*

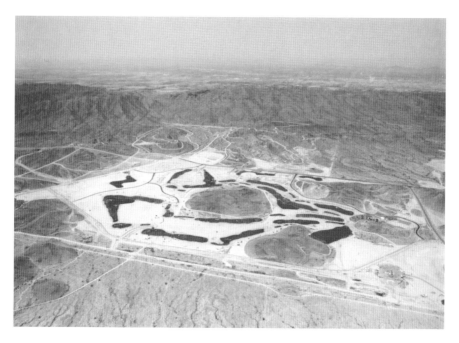

As in Ahwatukee before it, building a golf course, in this 1988 view looking north, was The Foothills' first priority. *Courtesy Jim Spadafore.*

community at the time—although not necessarily so today, to which communities like the northwest Valley's Anthem attest—golf courses created big, green open spaces and premium neighborhood opportunities while leveraging surrounding vistas; in The Foothills' case, these were particularly noteworthy. Kirk believes that in The Foothills, "We had the best of both worlds. What we offered was relatively rare anywhere in Phoenix. Mountain Park Ranch had beautiful topography but no golf. Lakewood had neither golf nor mountains. We had topography and golf, and the only thing we didn't build were lakes."

Well, give or take. A seven-hundred-room resort hotel was planned for the land northeast of Clubhouse Drive, as close as could be achieved to the southwest corner of Chandler Boulevard and 24th Street. With a golf course right across the road and another (today's Club West) soon to be nearby, the picturesque lower-desert setting seemed ideal. But timing is everything, and neither cachet shopping—indeed, even non-cachet shopping—nor any of Scottsdale's sexy amenities existed. "That's where those [resort] companies wanted to be," remembered Kirk. "We had a great site but were in the wrong part of town." Ultimately deemed to be too isolated, the land was rezoned for custom homes under Kirk's watch in the early 1990s.

Following the exact alignment of the proving grounds' major test tracks made perfect sense. International Harvester had already done pre-development work and had cut a road into South Mountain's foothills. The street corkscrewing up the mountain leading to the Eagle Ridge custom homesites near the northwest corner of Chandler Boulevard and Desert Foothills Parkway? Thank Harvester. "We merely took advantage of what they had already done," Kirk offered. "People might wonder how we could build into the hillside or cut the top of the mountain off, but we were only allowed [by the City of Phoenix] to go into those areas where Harvester had already carved with their equipment testing."

The Foothills Information Center, the former International Harvester Sales center now used exclusively as The Foothills' golf course clubhouse, contained a thirty-two-by-twenty-one-foot topographical display of the entire project that had some people doing a double-take on first sight. It is believed to have been the largest display of its kind ever built in Arizona, with each individual builder included on the topo map. The Foothills' widespread industry recognition included being voted the Best Master Planned Community by the Major Achievement in Merchandising Excellence (MAME) organization in 1989, an award given to honor excellence in central Arizona homebuilding. It was one of several awards for the project.

Vice-President of Sales Jim Spadafore, holding two MAME Awards, sits in front of the topographical display in 1990. *Courtesy Jim Spadafore.*

Currently chief operating officer of Camelot Homes, Tom Kirk reflected, "We really had a unique piece of property. We had the ability to build beyond normal limits of development because of what International Harvester did—they tore the place up! But one of my first impressions of that site came in the evening. It was quiet. It was dark. And it was beautiful. Today, some thirty years later, it's still quiet, dark—and beautiful. I thought that things would change with development, but the isolation created by South Mountain is amazing. It's really peaceful. And it's something that impressed me when I first started on the project which still holds true today. Development really has not impacted the serenity of The Foothills."

WHEN THE CAT'S AWAY

*A*fter twenty-five years of Ahwatukee Ranch winters, second owner Helen Brinton died in January 1960. Until the once-grand adobe house was demolished in 1975 it stood empty, save for one notable exception. During this time, former caretaker Byron Slawson continued to live in the small adobe house a few hundred yards away in which he and his wife had raised their five children, making sure that the citrus grove on the house's northeast side stayed watered and green. The vegetation in the big house's seventy-by-forty-foot enclosed courtyard didn't fare quite as well.

Enter John Ratliff. Earning a PhD under the GI Bill upon his return home from World War II, Ratliff became a Shakespearean professor of literature at his alma mater, the former Arizona State Teachers College. But restless and with time in his teaching schedule, he listened in 1957 when the son of another professor approached him about joining in an investment in a piece of land near Deer Valley. Ratliff "wagered" $2,000, and when his wager returned him $8,000 in cash a year later, he was hooked.

The former professor recalled, "I thought, 'Holy smokes, I'm not doing *that* well as a teacher.' Of course, it almost became my undoing because I was so tickled that I thought deals were all going to be that good. But of course the next one *wasn't*," he said with a laugh.

"But that first one got to me," continued Ratliff. "I thought it was kind of fun. One thing led to another, and I got my real estate license in 1959 and a job the following year with O'Malley Investment Realty, one of the big firms

in the 1960s." All the while, the baritone-voiced educator continued making his Shakespearean presence known on the now-reclassified Arizona State University (ASU) campus.

With partners John Miller and Rick Muir, Ratilff formed a land investment syndicate and did progressively bigger and more lucrative deals. In the process, he became a giant in the land investment business. In 1969, Ratliff learned of the availability of the Ahwatukee Ranch property (the twelve-thousand-square-foot house on 1,200 acres) being sold by owner Albert Fong. Fong had purchased the land from Brinton's heirs in the early 1960s. Aware that there had already been a few less-than-reputable prior offers, Ratliff said, "I asked whether Fong, who lived in Hawaii, would be interested in a letter of recommendation. It suddenly occurred to me to ask Barry Goldwater, with whom I had a nodding acquaintance, to write the letter. I called his secretary—oddly enough, a Mrs. Eisenhower—and got this glowing letter from Goldwater saying, 'Dear Mr. Fong, I understand that my great friend John Ratliff is interested in buying your Ahwatukee Ranch property. John is one of those get-up-and-go, do-what-he-says individuals whose word is his bond. And by the way, if you're related to my good friend [Hawaiian senator] Hiram Fong, tell him that I said hello.' We got the ranch."

Ratiff's land syndicate on the Ahwatukee property included ASU past president (1933–59) Grady Gammage's widow, Kay, as well as Bernie Hoogestraat, who was partially involved in development of the master-planned community of Ocotillo. The group had owned the approximately 1,200 acres only for one year when local realtor Dick Zigman initiated a meeting with Presley Development Company and its principal, Randall Presley. While it seems obvious now, the investment was considered risky and the property remote at the time. The California developer purchased the ranchland in two separate transactions. Said Ratliff, "Presley was sufficiently concerned that he might be out there exploring things at the end of the world. He first bought half of the property and then came back and bought the other half."

In her will, Helen Brinton had deeded forty acres of land to Byron Slawson in a life-estate, on which he could continue to live for the rest of his life. Albert Fong, who had taken a liking to the gentle man during periodic visits to the property, told Slawson after the land changed hands that had he been aware of the life-estate status of Slawson's acreage he would have permanently deeded it to him. After the Ahwatukee property was sold to Presley in 1970, Fong flew Slawson and his youngest daughter, Burma, to

The Ahwatukee Ranch house as it appeared during the time of John Ratliff's ownership. *Courtesy Burma Slawson Evans family collection.*

Hawaii, Slawson's wife having died in 1965. Upon the former caretaker's death in 1976, his forty acres reverted back to Presley.

Over in Santa Barbara, California, Ratliff's twenty-year-old daughter, Judy, and her childhood friend Candy Wright had just completed two years at a local college and were about to transfer to ASU for their junior year. In conversation regarding potential living arrangements Judy's father, ninety-five at the time of this writing, suggested the old ranch house in the future Ahwatukee. "The first time I looked at it I said, 'Well this'd be cool,'" said Judy. "We did a little bit of investigating and realized that it wouldn't be such a big deal to get electricity going again and get one bathroom up and running. We determined that we were going to be able to do it so we just moved in, right before fall semester started in 1970."

The fastest way to and from the house was unencumbered by traffic—or paved roads, for that matter. "I'd get on the telephone pole road [Salt River Project's dirt right-of-way running north–south near the house, along the same easement on which it does today] and go right down toward the freeway at Elliot," recalled Judy. Referring to the property's relative isolation at the time, Judy remembered approaching the ranch house via Warner Road. "You really knew that you were getting to something when you could see the old garage out there up ahead."

Her impression of former caretaker Byron Slawson, father of a son and four grown daughters? "He was a doll—very sweet and very protective of two young women who were alone in the big house. He had things that he did around the ranch house, so he was often around. We were very neighborly and liked him very much."

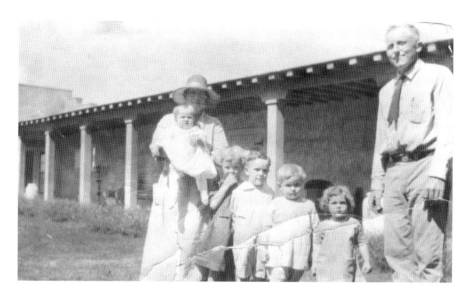

Byron and Matilda Slawson and their five children in the interior courtyard of the ranch house, circa 1920s. *Courtesy Burma Slawson Evans family collection.*

Of the seventeen-room, seven-bathroom, twelve-thousand-square-foot house, Judy remembered, "We'd park on the flagstone patio in the back and enter through the kitchen. It was enormous, and we put a picnic table in there. The kitchen sink and countertops all faced west, looking out at the citrus grove and the mountains behind it. [Today, that view would be of Ahwatukee Custom Estates.] It was a working kitchen for the servants. She [Helen Brinton] wasn't in there working so they hadn't put in granite or soapstone, but it was in good shape and very nice. All of the rooms were paneled in tongue-and-groove redwood, although we didn't open many of them up."

"Stairs outside led up to the roof over the dining room," said Judy. "There was a water tower up there. Frequently, we'd go up and sit on an old couch we'd brought up. There was a panoramic view all the way to the Superstition Mountains and Four Peaks. The views were spectacular!" With a flat roof over one of the bedrooms facing South Mountain, Judy recalled, "We'd throw a couple of old mattresses up there and that's where we'd foolishly sunbathe. Sometimes there'd be a gang of us girls sunbathing on the roof. We were forever getting buzzed by flyover planes; they were swooping low and gazing down to see what we had on. That was fun up to a point."

Since the ranch house was unoccupied when winter residents William and Virginia Ames, and later Helen Brinton, returned to their Midwest homes, it had no air conditioning. Said Judy:

The telephone pole road, as Judy Ratliff called it, bisects this view looking south from the Slawson house. *Courtesy Burma Slawson Evans family collection.*

Former Ahwatukee Ranch caretaker Byron Slawson in 1965, during the time that the ranch house sat empty. *Courtesy Burma Slawson Evans family collection.*

Summertime out there was quite a scene. We did do the old-fashioned thing of wrapping ourselves in wet sheets and lying in front of a blowing fan. It was pretty hot!

People at ASU didn't think anything of coming out to the house and spending time there. It was a great party house—we entertained a lot! I must say that Byron [Slawson] looked askance at how much we entertained and at how late people would leave with the racket going on. But Byron was always very accepting of all that, and we were never anything but 100 percent cordial. He was looking out for the place, and he was looking out for us. On at least one occasion, ASU's campus radio station announced, "There's a big party out at the end of Warner Road!" and my God, the number of people who showed up for that. I'll bet that night Byron was thinking, "I thought those were nice girls." The whole Valley turned out—it was just wild.

For a time, rumors surfaced that hippies were living in the big ranch house. Judy addressed that urban legend: "At one point we became aware that on Warner Road coming in, a school bus had turned up and there

was a couple from San Francisco with their small child and a dog—tie-dyed shirts and everything. They had left the city and parked their school bus, which was rigged up with a Victorian couch and other items. We made friends with them, and they came and parked their school bus out here [by the ranch house] for a while. And since we were always taking in people, I guess that this is how it got to be that, "There are a bunch of hippies living out there!" So it's official. At least for a while, the rumors were true.

But all good things must come to an end. In May 1973, one month after Ahwatukee's model-homes grand opening, it was time for Judy and Candy to leave. "It was about a year after [my ASU] graduation when they said you have to vacate the premises," said Judy. "I knew Presley was going to throw me out and was actually surprised that it lasted that long. I have no idea why they let us stay on there: I had been expecting somebody to show up for months and months, and finally one day this nice man came in and said 'I'm from Presley. You have to move out.'"

Of her time spent living at the Ahwatukee Ranch, Judy, sixty-eight years old at the time of this writing, reflected, "The stars lined up. Moving

Its days numbered by the time that Judy Ratliff moved out, the ranch house stood for fifty-four years before its 1975 demolition. *Courtesy Robert Peshall.*

seamlessly from the inside to the outside and it all being out in the desert like that—it really struck a chord and will remain a part of my imagination forever. It was a great and wonderful experience. At the time, of course, you just felt like you were totally way out in the boonies. Back then, we never even locked the place. It was absolutely amazing."

Two years later, the Ahwatukee Ranch house, in disrepair and crumbling from neglect after fifty-four years, was unceremoniously bulldozed into history.

THE EVOLUTION OF 48TH AND RAY

*I*t's been eight years and the shuttering of a local favorite near one of Ahwatukee Foothills' major intersections continues to reverberate. Rock Bottom Restaurant & Brewery, which served as a reliable eatery and watering hole on South 50th Street and Ray Road for twelve years, closed its doors in June 2011 and was at the time part of a wave of restaurant closings in and around the Ahwatukee Foothills area. The location is currently the site of a Mellow Mushroom restaurant.

The closing brought us full circle, at least where the southeast corner of South 48th Street and Ray Road is concerned. It wasn't long ago that South 48th Street was a dusty country lane with a different name, South 50th Street but a gleam in the City of Phoenix's eye and the land on the south side of Ray Road stretching from South 48th Street to the freeway was owned by one family. Indeed, as recently as 1994, firewood was being sold on the corner of the still-sleepy intersection.

For the genesis of today's bustling retail power center we travel all the way back to the end of World War I. The year 1918 saw the Tempe arrival of Texan Eli Fount Gates. Growing cotton near the eventual 56th Street and Ray Road, Gates soon purchased eighty acres of desert on what would become the southeast corner of 48th Street and Ray Road for his son, Herbert, a 1919 Tempe High School graduate.

The south branch of the Highline Canal, part of the water delivery system created with the advent of Roosevelt Dam in 1911, diagonally bisected the property. Owing to the slope away from South Mountain the land on the

southeast (downside) of the canal could be farmed, while the land on its other side could not—at least not without bringing water uphill so that it could flow back down. For the princely sum of $1,000, a two-bedroom house was constructed adjacent the canal, where Herbert Gates's three sons were born and raised. Gates cleared his land, purchased a few cows and slowly carved out a dairy farm. By the 1940s and on through the 1950s, both the acreage (then up to 155) and Gates's Desertland Farms had grown to be the second-largest dairy in the state of Arizona, after Laveen's Cheatham Dairy.

One mile to the east Herbert's son Eli, named for his grandfather, farmed his own 120 acres. South of the dairy, on the southeast corner of today's South 48th Street and West Chandler Boulevard, son Bill farmed another 80. Born in 1926, Eli was one of ten 1940 Kyrene Elementary School graduates and one of fifty-three from Tempe High School's class of '44. In 2004 he remembered Samuel Warner, who died in 1952 and after whom Warner Road was named, as "an old farmer." Eli recalled being a teenager during World War II and watching U.S. Army tanks being transported on flatbed trucks to the Phoenix Proving Grounds on which The Foothills would be built decades later. And according to Eli, construction of Interstate 10 in the mid-1960s was not a happy occasion, as it split the two family farms and involved acrimonious negotiations over property easements between his father and the Arizona Department of Transportation.

The lure of broken machinery eventually became a siren call to Eli, who began spending more and more time on Herbert's property troubleshooting dairy farm equipment. An avid collector, Eli accumulated myriad surplus machinery on the farm, with the scrap metal eventually outnumbering the cows. By the early 1970s his two non-farming businesses, Recycling Industries and Gila Materials, had obliterated all but a trace of the dairy business, with everything from jet airplane parts to rusting auto chassis to industrial-sized piston engines cluttering the property. Eli Gates called it a metal supply business; everyone else called it a junkyard. In 1972, the Department of Agriculture condemned the dairy.

A one-hundred-square-foot irrigation holding pen, used to store water for irrigating the dairy's alfafa crops on the northeast, or upper, side of the canal was constructed near the southeast corner of Hunter Drive (now South 48th Street) and Ray Road in the early 1950s. It accidently marked an Ahwatukee Foothills milestone, as the stored water provided a cool respite to the Gateses and other local farm families. Of the thousands of swimming pools that grace our village today, Herbert Gates could have arguably laid claim to having constructed the very first one.

Firewood as far as the eye can see graces the southeast corner of South 48th Street and Ray Road in 1994. *Submitted photo.*

The holding pen was eventually filled in and firewood was sold on the corner until 1994, when the land was purchased by Vestar Development Company. Said Mike Longstreth, first project manager of Mountain Park Ranch, "You didn't know what you were buying because at that time we were in the throes of recognizing environmental issues. The potential hazards of years of dumping batteries and oil loomed over what might be there on his [Gates's] property. Apparently it was okay because it was developed right away." Well, almost. Once purchased, it took Vestar about a year to clear the site for development, during which the City of Phoenix constructed South 50th Street.

In a nod to Rock Bottom Restaurant and Brewery, picture if you will in a *Twilight Zone* moment a young Herbert Gates working under a brutal desert sun, performing the backbreaking task of creating something out of nothing on his arid, sunbaked eighty acres of desert. Might Gates have harbored doubts that this vast acreage would ever amount to anything? Did he, in moments of quiet desperation one hundred summers ago, ponder the origin of that shard of glass that he'd found in the dirt—the one with the initials "R.B." on it?

WHO WERE THE TWO TOMS?

*T*he humble, soft-spoken giant in the annals of local history was born during World War I and lived a long full life in the Kyrene farming community, predecessor of today's village of Ahwatukee Foothills. He graced us with wonderfully detailed recollections of life in a time and place that most of us never knew firsthand but which are forever linked to the place that many of us call home today. His name was Tom Owens.

Who was Tom Owens? For starters, Tom was Samuel Warner's grandson. The Kansas native was one of the area's earliest homesteaders, arriving in 1908 and farming 160 acres at the southeast corner of 56th Street (now Priest Drive) and the road that bears his surname.

Tom was Reginald Elliott's son-in-law. Elliott arrived in the Valley in 1893. In 1914 he began homesteading 160 acres on the southeast corner of 56th Street and the street that took *his* surname (the second *t* was dropped in the process), including the land on which Costco stands today. Tom's 1940 marriage to Hazel Elliott, Reginald's daughter, was the original Warner-Elliott Loop. How long have the roads been known by their homesteaders' surnames? "Long as I can remember," laughed Owens, who was born in 1918.

Tom was a Kyrene School graduate, class of 1931, and Tempe High School graduate, class of 1935. He studied agriculture at Arizona State Teacher's College, now ASU, and then helped run the four-hundred-acre family farm near Ray and Kyrene Roads. A member of the boards of the Tempe Union

High School District, Kyrene Farm Bureau and Salt River Project, Tom was the first of four generations of Owenses to attend school in the Kyrene District. Reflective of the times in which he lived, Tom remembered that Arthur Hunter—"Mr. Hunter," as he always respectfully referred to him—felt strongly that women should be treated with respect and chivalry…and also had no place on a school board.

Tom (Jr.) was Tom Owens Sr.'s son. Tom Sr., a Missouri native, arrived in Arizona on the same day as its statehood, February 14, 1912. Tom Jr. remembered that as a child during the Roaring Twenties, "Every Saturday night we'd go out for dinner in either Phoenix or Tempe. That came to a screeching halt when the Depression hit." Tom Sr., president of the Kyrene Farm Bureau in 1931, persuaded the local land bank that held the mortgage on his farmland to stick with him during the lean years, eventually expanding the family farm to those four hundred acres near Ray Road and 56th Street.

Tom was Mac Owens's nephew. William Belden hired Uncle Mac in 1929 to oversee construction of a grand winter residence on a hilltop on three hundred acres that he owned in today's Mountain Park Ranch. Anticipating construction, Mac crafted seven thousand adobe bricks that sat forlornly in a field on Warner Road for twenty years after Belden and plans for his house died in 1930. Belden's widow added to the initial acreage, which eventually numbered 2,647. Thankfully, Mac ignored his grandmother's veiled advice upon announcing his impending marriage in 1920: "You can tell a pig the slop is hot but he won't believe you until he eats it," cautioned grandma. Mac and Viola were married for forty-nine years and had four children.

Tom was Jack Owens's cousin. Mac's son worked for twenty-nine years at International Harvester Corporation's Proving Grounds. That gave Tom a bird's-eye view of the land that would become the master-planned communities of The Foothills and Club West decades before development.

Tom counted Ahwatukee's unofficial first family, the Slawsons, as close friends. Patriarch Byron Slawson helped build, and then served as caretaker of, the Ahwatukee Ranch, the twelve-thousand-square-foot winter residence from which the village takes its name. All five Slawson children attended the Kyrene School, with son Bob in the same grade as Tom. With life off the farm centering on school and church, Tom spent his teenage years playing volleyball and socializing with friends in the shadow of the grand ranch house. Despite the Depression, "We made our own fun," Tom remembered with a smile.

Tom helped christen one of Ahwatukee's very first swimming pools (using the term loosely). Surf was up when the Owenses and other Kyrene farming

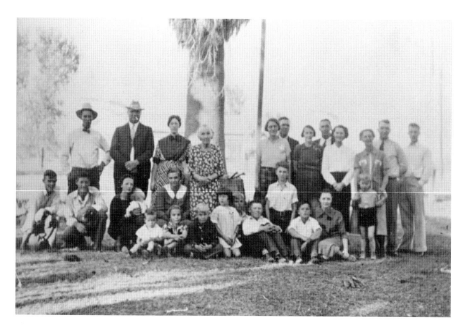

Thanksgiving 1936 included Tom Jr. (*kneeling left*), Tom Sr. (*standing back row, fourth man from the right*) and Uncle Mac (*with cigarette*). *Courtesy Owens family.*

families used an irrigation-water holding pen as the local beach, after a well was dug by landowner Lightning Transfer and Storage Company on land that it leased for farming. Recalled Tom, "They had geologists come out and tried digging wells two or three times but never did get any water. Then they got some ol' boy from Texas, a water witcher. He walked around, looked at the mountain and told them to dig 'here.' They had enough water to farm several hundred acres." Site of today's Ahwatukee Country Club golf course, the irrigated land was fed by the well and farmed through 1970 by Tempe sharecropper Marion Vance.

Tom never met William Ames, the internationally known Illinois dentist who built the Ahwatukee Ranch in 1921 and who died when Tom was three. But as a schoolchild Tom knew Mrs. Ames—"a very nice lady," he remembered—who threw a Christmas party every year for Kyrene School students. Tom had no specific recollection of having met Helen Brinton, who owned the Ahwatukee Ranch from 1935 to 1960. "I had to have met her because I was up at the Slawson house so much," he said. But if not, she would have been about the only person he missed.

Tom hiked the Ames Trail up South Mountain shortly after Byron Slawson built it. Reflecting back almost ninety years, Tom recalled in 2007, "As kids the

Boy Scouts used to hike over the top of the hill to an area we called Hidden Valley. There was a huge cottonwood tree—there has to be water for that to grow—and we'd cook our meal, have a picnic and do Boy Scout stuff up there. Especially in spring and way up into summer, there was a spring up there in Hieroglyphic Canyon. I've been up there when there was a pretty good stream of water almost year-round. My guess is it probably dried up." On the family farm, Tom dug up more Native American artifacts than he could count over the years while cultivating his fields.

Among Owens's many friends was one in particular whose Kyrene farming community journey paralleled his for most of their lives. They had a lot in common: Both of their grandfathers were born before the Civil War. One's great-grandfather was Kansas's governor *during* the war. Both of their families and Arizona statehood arrived at about the same time. They grew up and spent most of their lives a stone's throw from today's Ahwatukee Foothills, which each during the latter part of their lives ended up calling home for more than 25 years. Combined, their 182 years witnessed the transformation of the area from its dusty, backroad infancy as the Kyrene farming community to the built-out hustle and bustle of today's Phoenix—and everything in between. Grade school classmates, they remained lifelong friends.

Who was Tom Carney? Born in Globe, Arizona, in 1917, he was one year Owens's senior. Both Toms' histories were linked by B.B. Moeur. A horse-and-buggy country doctor with a Tempe practice, Moeur brought Tom Owens's future wife, Hazel Elliott, into the world in 1920 and over the years did the same for Tom Carney and his five siblings. Moeur, a successful businessman as well as Arizona's governor in the mid-1930s, owned an eighty-acre dairy farm on part of the site of Tempe's Ken McDonald Golf Course.

In 1926 the Carney family traded in their nine-dollar-per-month rental house for a lease on Moeur's farm, where Tom spent most of his childhood. He arose at 3:00 a.m. to milk cows and remembered working in the fields as a youngster, exchanging friendly waves with a young Tom Owens and his father as they drove past the Moeur place to their own family farm a few miles to the south. Carney's father, a man clearly ahead of his time, moved the family to Oregon in 1928 after deciding that life in the Valley of the Sun had become too crowded (and too expensive). The family was back on the Moeur farm a year and a half later.

Members of the Kyrene class of '31, both Toms fondly described idyllic childhoods centered on farm, school and church activities. A family picnic

Classmates and lifelong friends, Tom Owens is the boy on the extreme right, with Tom Carney standing next to him. *Courtesy Owens family.*

and father-and-son softball game highlighted the memorable last day of the school year. Both Toms went on to graduate from Tempe High School in the class of 1935.

Long before there was an Ahwatukee Foothills, Owens, Carney and their friends had the area all to themselves. Owens remembered at least one Prohibition speakeasy rumored to be tucked deep into the foothills of South Mountain, and Carney recalled picnicking on the land that became a General Motors proving grounds—today's Foothills and Club West—in the '20s and '30s. Swimming, fishing and waterskiing-by-pickup-truck in the Kyrene farming community's irrigation canals were summertime rituals.

Remembered Carney, "In high school I got my driver's license. We'd hook up one hundred feet of #9 wire to a board, the pickup would take off and you'd skid up and down the canal on the board. We called it skateboarding. Later on, we got sophisticated and built skis by getting some old boots and bolting them onto wooden "skiis." We weren't very good at skiing—got pretty banged up but never broke a leg."

Both Toms were part of a large, close-knit group that celebrated Easter with a sunrise service and cookout breakfast in the hills north of today's Ray Road near 32nd Street. Despite growing up in the throes of the Depression, "We weren't poor, just limited in cash," Carney wryly observed. Owens's reminiscences seemingly always ended with a hearty laugh, painting a vivid picture of a large circle of friends who were never at a loss for fun and warm camaraderie.

Graduating from Arizona State Teachers College in 1939, Tom Carney was drafted into the U.S. Army. A big party awaited him as he was welcomed home for a weekend in late 1941 on his initial furlough from Washington, D.C., but the festivities were short-lived. The party

Left to right: Tom Carney, Clyde Wilgford and Tom Owens, friends for life in this undated photo. *Courtesy Owens family*.

was on a Friday night and that Sunday morning dawned as "a Day that Will Live in Infamy"—the bombing of Pearl Harbor. Discharged from the service at the war's end, Carney tried his own hand at farming before beginning the first of his twenty-nine years teaching Phoenix middle school students in 1950. Working around the school calendar, Carney started Tempe Tree Farm in 1955, which at its peak grew five thousand shade trees. The versatile entrepreneur also built and sold a few small apartment buildings.

Still referring to the elders of their youth by the same respectful "Mr." or "Mrs." with which they addressed them generations ago, the two Toms could draw on their firsthand knowledge of the movers and shakers in Ahwatukee Foothills' history. Arthur Hunter, an early homesteader for whom Hunter Drive, predecessor of South 48th Street, was named, was an imposing man who put the fear of God into both youths as their Sunday school teacher. Beginning in 1916 with Tom Owens's grandfather, Samuel Warner, several Owens family members, including Tom's father and Tom, served on the school board.

Both Toms spent countless hours playing volleyball in a sandy wash near the Slawson house, in proximity to the twelve-thousand-square-foot ranch house from which Ahwatukee takes its name. The Slawson patriarch and caretaker of the property, Byron, occasionally gave them guided tours of the big house when it was empty during the summer. What was it like? "It was nice. But as kids, what did we care about a big old house?" Carney asked rhetorically.

Aware of Del Webb's success with Sun City, which opened in 1960 northwest of Phoenix and proved that a strong demand for desert retirement housing existed, Carney wasn't surprised when development of Ahwatukee started in the early 1970s. Carney felt that it was likely to succeed eventually. Hazel Owens, on the other hand, remembered being told by a local realtor around that time that hundreds of houses would be built west of Interstate 10. "I think you're mistaken!" Hazel insisted, as she laughed in retrospect about the seeming implausibility of development where, for most of her life, only the Ahwatukee Ranch house, Slawson home, Vance's irrigated fields and the Collier-Evans Ranch existed.

"My father always said, 'If someone offers you a million dollars for this old place, you ought to sell,'" remembered Tom Owens. When he sold the four-hundred-acre farm in January 1972, he said, "We were able to do some things that we might not otherwise have been able to," he said. And yet, he lamented, "I kicked myself for not waiting and holding on to the land

longer." (Not long thereafter, nearby land was priced by the square foot.) "But the good old days were great, and I enjoyed every minute of them," Owens said contentedly in 2007.

For his part, Tom Carney offered that he had been hiking in the South Mountain area for eighty years by his count. At the age of ninety, he summed things up: "Both horses and motorcycles aren't what they used to be. I used to get on a horse and the ride was smooth as a rocking chair. Now, it's all bumpy and I can hardly stay on. Same thing with a motorcycle. I used to zip all around with no problem, but I tried one about five years ago [in his mid-eighties] and could hardly stay on the thing," he said, laughingly ruling out age as a factor.

Both kind and humble men, Tom Owens and Tom Carney epitomized long lives well lived. Through their generosity of spirit, they greatly enhanced what we know of the pre–Ahwatukee Foothills area and helped us to connect many of the threads of its history. At age eighty-nine, following sixty-seven years of marriage, Owens died in 2008. Two years later Tom Carney, married sixty-six years to Madeline, died at age ninety-three. Both live on through our enhanced knowledge, perspective and appreciation for a time and place that we never knew firsthand but that serves as the foundation of the series of master-planned communities that today almost ninety thousand people call home.

To Be or Not to Be—Annexed!

*T*hat was the question in the early 1980s, before the master-planned communities of Mountain Park Ranch, Lakewood, the Foothills and Club West existed. Ahwatukee residents struggled with the idea of their small, bucolic hamlet being swallowed up by the city of Phoenix. Back when the population was less than five thousand, folks were concerned that the small-town lifestyle they had come to savor would change, and not necessarily for the better, if the City of Phoenix were in charge.

The story of Ahwatukee's annexation (the absorption of a smaller municipality into a larger one) begins in early 1972 with a handshake between Phoenix mayor John Driggs and Presley Development Company of Arizona attorney Bob Stark, Driggs's former high school classmate. Randall Presley, a California builder with a long and impressive track record, knew that development of the 2,080 acres of high-ground desert that he'd purchased on the south side of South Mountain hinged on his ability to find a way to bring water to it. No water, no development—it was that simple.

Phoenix had not been Presley's first choice. Before the freeway was built, the few inhabitants of the land that became our village had an unincorporated Tempe address starting with "Rural Delivery" and followed by a number. The City of Tempe rejected Presley's overtures seeking water for his proposed community in exchange for a future annexation in the summer of 1971, with the Tempe City Council stating for the record that it was striving just to keep up with growth on the east side of the freeway. Interstate 10 represented not only a physical barrier but a psychological one as well, according to one city

Old meets new at the intersection of South 48th Street and East Chandler Boulevard in this 1994 view looking south. *Submitted photo.*

council member. Likewise, noted the City of Chandler, a sprawling but mostly agricultural municipality at the time.

Formerly an officer with large residential lender Western Savings and Loan, John Driggs and Presley counsel Bob Stark had known each other since their high school days in Phoenix. The attorney, a member of Maricopa County's board of supervisors who abstained from any county vote involving his client, made the case that development was impossible without Phoenix city water. Stark stressed that Presley had determined that it could build its residential housing development only if it had access to a city water supply. Part of his request was that Presley be allowed to begin construction under less restrictive Maricopa County building codes in exchange for the developer's agreement to cooperate with the city in a future annexation.

The city's motivation? Ironically, in the days before "urban sprawl" was a part of the lexicon, Phoenix's policy since the 1950s had been to annex all adjacent areas as they became urbanized. City Manager John Wentz explained in 1974 that "the object is to control planning, such as land use and transportation systems, so that they will not become detrimental to the city, and to prevent a ring of independent cities around Phoenix." And should a lucrative tax revenue base accompany an annexation—by no means a sure thing in Ahwatukee's case—so much the better.

Referring to the land on which Ahwatukee would be built, Driggs said, "I was only as familiar with it as anybody else who drove the [I-10] freeway to Tucson." But when he and Assistant City Manager Marvin Andrews looked at a large map on an office wall and specifically at the narrow strip of land between the eastern portion of South Mountain and the freeway, the mayor saw an opening.

Previous Phoenix annexations had been to the west and north of the city, but Driggs recognized a window of opportunity to expand the city's limits beyond what until that time had been another physical and psychological barrier: South Mountain. The former mayor recalled, "We had never even thought about annexation to the south because South Mountain was that natural barrier, and there had never been anything there to be thinking about. But looking at that narrow neck of land [between the mountain and freeway], it struck me that if Phoenix was ever to consider annexation activity to the south this was the chance." Driggs summed up his view regarding both the opportunity to extend Phoenix's reach beyond South Mountain and the possibility of losing out to other adjoining cities should they change their mind, deciding instead to annex the future Ahwatukee, saying, "I didn't want to be cut off at the pass."

Driggs didn't concern himself with the details of Ahwatukee water procurement, knowing that his management team would work those out with Presley. Enter Buck Weber, whose Weber Water Resources' three wells near today's Loop 202 intersection with Interstate 10 provided the solution (see page 58).

With nothing more than their handshake sealing the deal, Driggs and Stark reached an agreement: in exchange for water and sewer service from the city, Phoenix would receive Presley's full support and cooperation in a future annexation. How could something so monumental be accomplished without anything in writing? "With a little bit of frontier spirit," said Driggs, who died in 2014. "A handshake, trust and reliance." Driggs viewed the land south of South Mountain as the city's "ace in the hole." But just to make it official, the Phoenix City Council approved the verbal agreement on July 12, 1972, stating that it would "provide water and sewer service to a development known as Ahwatukee." In exchange for Presley building the infrastructure for water delivery, the city would reimburse the developer. Presley could now break ground south of the mountain as a part of the City of Phoenix water system.

Ahwatukee's first homeowners arrived in the fall of 1973. Early the following year the Phoenix City Council agreed to install fire hydrants along the thin network of streets, further setting the stage for annexation. "In

effect, we are making them [Ahwatukee] captive," City Manager Wentz said at the time. Not everyone at the city echoed the wisdom of that statement. The Phoenix Planning Commission expressed reservations to the council about perpetuating urban sprawl by extending city services beyond South Mountain. And the city's finance manager noted that the lag between annexation and tax revenue collection could be problematic. "If we annexed before the commercial property is developed, it would cost the city money because we wouldn't collect any sales taxes from the businesses," said City Manager Tony Vincente.

Per Driggs's and Stark's handshake agreement, Presley broke ground under the jurisdiction of Maricopa County, which offered a less restrictive developmental environment in which to start initial construction. But not everyone at the county was completely sold on the idea either. "Ahwatukee

This northwest-facing partial view of Fort Ahwatukee at South 48th Street and an unpaved Elliot Road depicts the project's western border in 1974. *Courtesy Peggy Geisler.*

Plans Called Frightening" ran a headline in the July 26, 1974 *Arizona Republic*, referring to a Maricopa County Planning and Zoning meeting at which Commissioner Mike Enriquez described the development as too dense, stating, "I don't know how it was originally approved. It's a frightening development."

As the tiny community slowly grew and a Mayberry-like feel evolved, Tempe had second thoughts about its earlier decision to reject the prospect of a future annexation. Said one Tempe mayoral candidate in 1974, "The people I know out in Ahwatukee would like to come into our city, not into the city of Phoenix, and we need to carefully examine that. You can't just say no and bury your head." Countered Presley Development of Arizona president Dan Verska, who oversaw Ahwatukee's initial development, "We have a verbal gentleman's agreement with the city [of Phoenix] that eventually we'll be annexed."

As Ahwatukee's population approached two thousand in March 1978, a lone Circle K on Elliot Road stood as the future village's only retail establishment and potential sales tax generator. Perhaps aware of Tempe's reservations, Mayor Driggs's successor, Margaret Hance, spearheaded Phoenix's midnight annexation of a twenty-foot-wide strip of land adjacent Interstate 10 from Elliot to Ray Roads, effectively preventing annexation by any other municipality.

A July 1981 "Annexation Implications" report by the Phoenix Planning Department examined everything from land use to traffic projections to refuse collection in the future Ahwatukee Foothills. Projecting an eventual saturation of 86,000 people—pretty darn close to today's official 87,000-plus count—the report noted that although 434 high school–age students in Ahwatukee attended Tempe's Corona del Sol, fifty hometown acres had been set aside for a future high school (the as-yet-unnamed and unbuilt Mountain Pointe); 1980 census figures put the combined population of what would become Mountain Park Ranch and Lakewood at 19, with the crowd in the future Foothills and Club West numbering 11. Also contained in the now thirty-eight-year-old report was a recommendation for a six-lane controlled access road along Pecos Road, connecting the area with 51st Avenue on the west side of town.

In order to annex, Phoenix needed the approval of the owners of 50 percent, plus $1, of Ahwatukee's assessed property valuation. Sentiment was running three-to-one against when the city announced in July 1982 that it had decided not to pursue annexation. A few weeks later, "Annexation Stuns Ahwatukee" blared a headline in the *Phoenix Gazette*, referring to

Early Ahwatukee's leisurely pace belied the growth that was to come. Here two riders pass The Lakes Golf Course on South 48th Street. *Courtesy* Ahwatukee Foothills News.

Phoenix's surprise annexation of 16.5 square miles surrounding Ahwatukee proper, in effect boxing it in as a Maricopa County island. The swing vote? International Harvester Company viewed the same geographic isolation that made conditions ideal for a heavy equipment testing facility as a potential liability should the land to its east develop within the city. At the company's request, its 6.5 square miles on which the Foothills and Club West would eventually be built were included in the "stunning" August 1982 annexation, ensuring future accessibility to and from the proving grounds.

Then as now with the construction of the South Mountain Loop 202 freeway, emotions ran high. Ahwatukee resident Barney Jung led a group of concerned homeowners that mounted a grass-roots initiative to incorporate Ahwatukee and keep it out of the city of Phoenix. Taking ACTION (Ahwatukee Committee To Incorporate Our Neighborhood), the group maintained that only by keeping essential services such as police and fire protection and water and trash collection privatized could taxes remain low and the serene, small-town lifestyle for which residents had moved be preserved. With incorporation would presumably have come Ahwatukee's election of its own mayor and governing body.

Under Maricopa County's jurisdiction, Ahwatukee residents paid Rural Metro a monthly fee for fire protection, paid various providers for trash

With no public library, a traveling bookmobile periodically served Ahwatukee's residents prior to annexation. *Courtesy Robert Peshall.*

collection and were under the watch of the county's Sheriff's Department. Particularly regarding the latter, with one officer responsible for the area between Baseline Road and the Gila Indian Community and Ahwatukee and Mesa's Power Road, response time was sometimes measured in hours. Adequate protection was a big concern for annexation proponents, who argued that services would only improve and be more cost-effective under Phoenix's umbrella. At least one nearby landowner, International Harvester, saw distinct advantages to being a part of Phoenix rather than Maricopa County. Access to proven city services (particularly police and fire protection), a prestigious image—Phoenix would eventually be rated an "All American City" by the Bertelsmann-Stiftung international organization in 1993—and a strong municipal bond rating were all reasons supporting annexation.

Charles Keating's Continental Homes' 1980 purchase of the 2,670-acre Pima Ranch was accompanied by the developer's request that Phoenix annex the property, realizing that access to city water would greatly speed up and simplify the development process. Thus, the eventual Mountain Park Ranch was part of the 1982 annexation as off-site development was occurring but before the first shovel of dirt had been turned on the project itself. Annexation was again on Keating's mind when he acquired the square-mile Collier-Evans Ranch a few years later. The City of Phoenix, by then convinced of the future village's potential success, was eager to welcome the future Lakewood under its umbrella.

One full-page ad in the March 15, 1984 edition of the *Ahwatukee News* touted the benefits of incorporation, while opposite it, another full-page ad extolled the benefits of annexation. But by then, Presley Development Company still controlled 10 percent of Ahwatukee's land, and its position had evolved from one of cooperation to neutrality to full-blown proponent of annexation based on the increasing difficulty of doing business in a county island surrounded by city land. Phoenix's 1984 partial annexation included the Ahwatukee Country Club Golf Course, in which the out-of-bounds stakes became the city limits. That brought a lawsuit by ACTION, which wound its way through the courts for the next three years. At first ruled unconstitutional, the city's land grab was ultimately upheld in 1987 by the Arizona Supreme Court.

That same year the final chapter of Ahwatukee's annexation was written. Today's remaining county-island includes the former Grace Inn (now the Four Points by Sheraton hotel) and the majority of the adjacent Ahwatukee Plaza shopping plaza. The properties' owner and Ahwatukee's largest water user at the time was developer Bill Grace, whose one vote could have determined the outcome of Phoenix's quest. In a letter to the merchants in Ahwatukee Plaza, Grace wrote that when he asked City of Phoenix officials to show how he and his tenants would be better off by being a part of the city, they admitted that there was no way that they could do that. Thus, the developer found it more advantageous to remain a part of the county rather than be absorbed by the city, in the process saving a substantial amount in property taxes. Grace abstained from the vote on annexation.

With his land excluded from the city's proposal and the eventual village taking shape in the form of Mountain Park Ranch, Lakewood and The Foothills (prior to the sale of its Phase III, the future Club West), the city's final annexation proposal succeeded. The county island at the heart of the original Ahwatukee—with adjacent businesses Original Burrito Company (a part of Phoenix) and next-door neighbor Walgreens in the county—remains such to this day.

By early 1988, Ahwatukee's long and torturous annexation process was over. In the end, many proponents of incorporation conceded that annexation made sense. "I don't think we ever envisioned ninety thousand people here," said early businessman (Millie's Hallmark) and longtime resident Hank Wynberg. Ahwatukee Security founder and president Mike Collins reflected, "City services and city police: There's no way we could be this big without them." The final transition from county to city

came when the linguistically challenging "Ahwatukee" disappeared as a mailing address, replaced by the blander but all-encompassing big city of "Phoenix, Arizona."

With its complicated and at times emotionally charged journey finally put to rest, residents received city trash cans, and a library and firehouse were eventually built. But given that the future village was still perceived to be remote even in the late 1980s, city police response times at first were no better than those of the Maricopa County Sheriff's Department. Periodically, if you were lucky, it could still be categorized as same-day service.

LIVABILITY AND THE TEST OF TIME

"A dream project"…"Great piece of land with a great team of designers"…
"Total commitment to total quality"…"Fated to be a great community."

These are but a few of the superlatives heaped upon Mountain Park Ranch, the 2,647-acre master-planned community in the heart of the Village of Ahwatukee Foothills. The development's official groundbreaking was in March 1984, and a look back whisks us on a journey illuminating just how we got from there to here.

The story begins in 1929, when New York captain of industry William Belden purchased three hundred acres of pristine desert a mile south of the area's first and only winter residence, Casa de Sueños—later to be renamed the Ahwatukee Ranch. Belden, founder of a company that made fan belts for the nascent automobile industry, had a seat on the New York Stock Exchange and intended to build his own grand winter estate on a hill overlooking today's Mountain Park Apartments on Ray Road. The cost of the twelve-thousand-square-foot house was projected to be a tidy $50,000.

Two miles to the west, Dr. Alexander Chandler—founder of the city that bears his name—also had big plans for a large swath of land he had acquired near today's intersection of East Chandler Boulevard and South 32nd Street. Chandler enlisted nationally known architect Frank Lloyd Wright, fresh off completion of the design of the concrete blocks used in constructing Phoenix's Arizona Biltmore resort hotel, to draw up plans for a sprawling three-hundred-room resort on six hundred acres. Wright, his family and a

team of architects set out from Wisconsin in a driving snowstorm in January 1929 and set up Camp Ocotillo in what would become the western edge of Mountain Park Ranch fifty-five years later. There they spent the next four months drawing up plans for Chandler's San Marcos in the Desert resort. As the weather heated up they broke camp in May, planning on a fall return. Alas, when that October's stock market crash intruded Chandler's investors withdrew their backing. The resort was never built.

Belden's property was known as Pima Ranch due to its proximity to a nearby trail called Pima Road. The ranch name stuck but the street name didn't. A proliferation of Pima Roads, named for Arizona's cotton cash crop at the time, prompted the renaming of several around the Valley. Pima Road became Ray Road in the early 1930s in honor of a pioneering East Valley farm family. When William Belden died unexpectedly in the summer of 1930, plans for the grand house were abandoned. Instead his widow, Helena, and son, Billy, spent the next forty years sporadically visiting the small outbuildings that had been constructed at the bottom of the hill. Over the years, the land grew to encompass 2,647 acres but remained largely undisturbed.

Utah alfalfa farmer and land investor LeRoy Smith acquired Pima Ranch from the Belden estate upon the death of Belden's widow in 1972. Ahwatukee had just broken ground on its country club golf course, and houses were a year away. The area was considered remote and far removed from the cities of Phoenix and Tempe, and future success was by no means assured. Its growth into today's 35.8-square-mile village of Ahwatukee Foothills was unimaginable.

To help increase his property's marketability LeRoy Smith hired A. Wayne Smith (no relation), who had first put pencil to desert in designing Ahwatukee's master plan in 1971. Six years later, the land planner and landscape architect created what would become the first master plan of the eventual Mountain Park Ranch. By the late 1970s, Charles Keating's American Continental Corporation's Continental Homes, which was finishing up development of Mesa's Dobson Ranch, was looking for more land on which to build another master-planned community. Keating saw Pima Ranch as a perfect fit, and Continental purchased the 2,647-acre parcel from LeRoy Smith via a series of options over the next several years.

Critical to the development of Pima Ranch was sewer and water access. Neither was an option in unincorporated Maricopa County. Said Continental Homes' first project manager, Mike Longstreth, "We needed to tie into City of Phoenix sewer and water systems, but the city wouldn't allow it unless you were part of the city. The water line into Ahwatukee was

Winter visitors Helena Belden and son Billy (*middle*), with friend Jack Owens, picnic on the future Mountain Park Ranch in 1934. *Courtesy Jack Owens.*

woefully inadequate for anything else, and the city line was three or four miles away near Baseline Road. A lot of negative annexation spirit existed, so we had to persuade the city that this [Mountain Park Ranch] was a really good idea." Emphasizing Continental's track record with Dobson Ranch and The Lakes master-planned communities, as well as the creativity of A. Wayne Smith's 1977 master plan, Continental made its pitch for immediate annexation to the Phoenix City Council.

One additional argument was made. Utilizing three aerial photographs showing how rapidly parts of Tempe and Chandler had developed over a five-year period, a comparison was made with the lack of development on the west side of Interstate 10. The difference? The land east of the interstate was under a municipality's jurisdiction, while the land west of it was in an unincorporated part of the county. The council voted unanimously in Continental's favor to annex the Pima Ranch land. When the 4.3-square-mile parcel became part of the City of Phoenix in August 1980—before one blade of dirt had been turned—it ushered in the largest master-planned community within the city's history up to that time.

Freeway access from Ray Road didn't yet exist, and the remnants of its dusty trail ended just west of South 48th Street. As such, the entrance to the project was located at Williams Field Road (subsequently renamed East

Chandler Boulevard) and South 40th Street, leading to a newly carved-out Mountain Parkway. A road navigating substantial foothills, as the latter does in connecting Chandler Boulevard and Ray Road today, was a radical design concept for its time.

Its proximity to South Mountain and its own topography posed both the property's biggest selling point and its biggest pre-development challenge: drainage engineering to manage a large volume of potential floodwater so that it wouldn't increase the flow on adjacent properties. Said Longstreth, "You're picking up an apron of water off of the side of South Mountain and passing it south to the Gila River. There was massive sheet-flow crossing forty acres near the project entrance on Williams Field Road, and it all had to be internally managed. We couldn't develop the property without channeling the water. That's why the drainage channels are under those big power lines." And since those overhead power lines came with the territory along the 41st Street alignment, drainage followed the power lines as much as it could.

The sizable carrying costs of initial off-site improvements, including water and sewer connections, that Continental agreed to build in exchange for City of Phoenix reimbursement, led to a joint-venture partnership with Genstar Corporation. The Canadian company had properties in San Diego, was looking to expand its land development operation into Arizona and approached Continental Homes about buying the property outright. Charles Keating, aware that the capital costs of the enormous improvements Continental had underwritten were more than it could comfortably carry, agreed to a joint-venture arrangement. In 1982 Genstar bought out Continental Homes' 50 percent share, but the latter's homebuilding arm became a key builder in several Mountain Park Ranch subdivisions. Keating, a midwesterner whose projects typically reflected his affinity for water, subsequently found the square-mile Collier-Evans Ranch directly south of the project more to his liking. American Continental's 1984 purchase of that property then resulted in the company's development of Lakewood.

Project Manager Mike Longstreth pointed out that the entirely different topography of the two properties meant that while the flat-as-a-pancake Collier-Evans Ranch could accommodate large lakes, the foothills-laden Pima Ranch had room for only smaller ponds. Thus, the two properties begat Lakewood and Mountain Park Ranch, respectively.

In 1982, the man whose influence would shape Mountain Park Ranch more than anyone before or since arrived on the scene. Ron Lane had spent a few years overseeing the master planning of a 6,500-acre property in Simi

Valley, California, for the True West Company. The land was very hilly, and a variety of environmental impact studies had to be done in order to get plan and zoning approval. After two years on the job, Lane had become something of an expert on the unique complexities and challenges of developing that type of land.

Lane was hired by Genstar in La Jolla, California, to serve as Mountain Park Ranch's project manager. In late 1982 he met with A. Wayne Smith and began familiarizing himself with the property. (Coincidently, Lane's office on Camelback Road was one hundred feet from that of American Continental.) In the spring of 1983 Lane rented a Jeep and drove all around the former Pima Ranch. Recalled Lane, "There were no roads, but the vegetation wasn't that bad and I could get around easily enough. It certainly was untouched land, and there was nothing out there except for a dairy farm [Goldman's; see page 66]. Riding all alone for a while I heard someone taking target practice, so I figured I'd better get out of there."

Lane's initial thought was that the property was a long way from civilization, although Ahwatukee bordered it on the north. "It was a question of getting engineering plans done, getting an interesting builder and coming up with a program of amenities. You start with: Where are you building? Where are the possible main entrances to the project? Basically there were two: One was Ray Road, but there were no freeway ramps at the time and the only thing up there then was a junkyard. There was freeway access at Williams Field Road, so we put one of the main entrances there at 40th Street. Had there been freeway access to the north, I probably would have done Ray."

Two conditions of Mountain Park Ranch's development were that storm water runoff beyond the project's borders not exceed that of pre-development and that no construction occur beyond 10 percent of a foothill's slope. Under Lane's oversight, most of the land's natural drainage channels were left open and lined with riprap (boulders and crushed rock). "It was the hydrologic engineer's vision," Lane remembered. "When water is coming off the mountain you have to slow it down; otherwise it will erode everything. So, I used these riprap channels, putting the boulders in to slow the speed of the water and reduce erosion on the banks. The land beside it is useless, for homebuilding anyway, since you can't build under power lines."

The location of the community's two large parks, Sun Ray and Vista Canyon, was based on water flow. "We built both parks as retention basins for flooding," Lane said. "Each location is based on where the water is coming from, down those riprap channels, and both parks are a perfect

place to do that. They're designed to fill up with water and disperse it at a measured rate—the ballfields being under water for two or three days is by design."

"Once we got the parks in," said Lane, "I wanted a trail system there. We did a substantial amount of landscaping so that it's not just dirt but a fairly attractive park-like environment. Just having the mountains wasn't going to do it." Lane had eight-foot-wide curvilinear recreation paths paved alongside the drainage channels, using desert landscaping. "I wanted curvilinear wherever feasible so that I could have landscaping on both sides of it," recalled Lane. Doing so turned a negative—overhead power lines crossing the property—into a positive. A few small lakes with fountains surrounded by grass and benches were strategically located in the drainage channels.

In implementing A. Wayne Smith's master plan Lane made one significant change: tightening up Ray Road as it looped west toward Chandler Boulevard. Lane created a custom-home feel in several non-custom subdivisions using zig-zag common area walls and those curvilinear

Mountain Park Ranch groundbreaking on March 9, 1984. *Left to right*: Ron Lane, Phoenix councilman Calvin Goode and Genstar executive Bob McCloud. *Courtesy Ron Lane.*

sidewalks wherever possible. "I didn't want to have all these mile-long walls and bland-looking streets." he said. Attractive signage greeted motorists at the project's key entry points.

"As I was planning the 6,500-acre project [in California, prior to Mountain Park Ranch]," Lane continued, "if I had a design or construction issue I'd simply drive around Irvine and ask myself, 'How did *they* do it?' In Irvine, there are centers with swimming pools and tennis courts. That's where I got the idea for Mountain Park Ranch," he said, referring to its three community recreation centers. Prominent Valley architect Vern Swaback designed the centers and drew up builders' architectural guidelines. Swaback, the youngest of Frank Lloyd Wright's apprentices and a world-renowned architect in his own right, worked with Lane in designing guidelines for the community's custom subdivisions, such as Canyon Reserve.

Jan Baratta, a former Genstar engineer who reported to Lane, credits him for the development's unparalleled livability. "It was his baby, and he kept tight control of the reins. Ron knew *precisely* what he wanted and didn't value-engineer things out of the plan. He didn't cut corners. Drive through the community today and you're not going to find better infrastructure. The drainage facilities still look brand new. There is a quality look to everything."

For his part, Lane reflected, "Nobody from [California] headquarters bothered me—in fact, at one point I didn't hear from the head office for six months. I pretty much had free rein. I came from Irvine [California], and I knew what it was like there: everything *worked*. I thought that there's no reason this can't be the same. I wanted a desert palette, and if I didn't like a particular plant, even though I had approved it earlier, we would rip it out. It happened a few times; it was my mistake." Laughing, he said, "There was a budget for landscaping, but I *made* the budget. You don't sell houses with bare rights-of-way!"

After the project's grand opening, a builders' grand opening was held in the fall of 1984 involving the development's initial three builders: Coventry Homes, Pulte and Wood Brothers (Continental Homes started building later). According to Lane, market segmentation was an important concept. "That's how you pick the builders," he said. "'What buyer do they aim for?' Pulte was lower-end, Coventry targeted the middle and Wood Brothers went for the higher-end. That helped me decide which piece of land went with which type of buyer." The first homeowners, Lorraine and Bill Walkley, moved into the community's first subdivision in April 1985. Sheep outnumbered people, with winter pasturing the main activity on the land on which Safeway at Chandler Boulevard at South 40th Street would eventually be built.

This page: Challenging topography made integrating subdivisions into open spaces critical. Both views are of the Pacific Scene development (1985 and 2018), south of Sun Ray Park. *Submitted photos*.

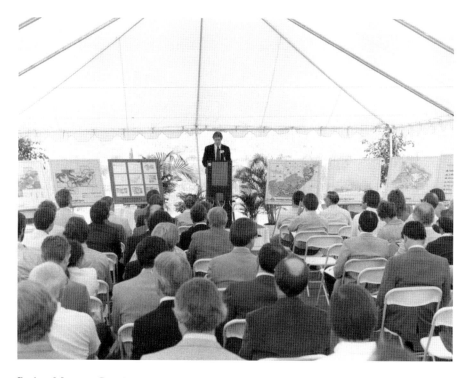

Project Manager Ron Lane, speaking at the ceremonial groundbreaking, made attention to detail his mission at Mountain Park Ranch. *Courtesy Ron Lane.*

As the roaring 1980s turned into the tight-money 1990s Lane was forced to become more creative. "Each builder had its own sales office and model homes. Typically, we sold a parcel of land for a builder's subdivision, and the builder would submit its houses for architectural approval. In the early '90s, builders didn't have the funding, so we would work with the builder. They'd design the subdivision, we'd build everything but the houses in the subdivision [sewer hookups, streets and sidewalks] and the builder would select the individual lots. My boss didn't want to do that. I said, 'We have no choice—otherwise we'd be just sitting on the land.' We got very good at making that work."

"We'd advertise at least a half-page in the newspaper every Sunday," Lane continued, "naming all the builders along with lot prices. From the first house, I tracked all the houses sold. We averaged forty-five sold per month for nine and a half years. We were way ahead of the competition."

With more than seven thousand homes, apartments, condos and businesses in fifty-three subdivisions today, the master-planned community has won numerous

To noted Valley architect Vern Swaback, the difference between Mountain Park Ranch and other master-planned communities was, "There were people who cared." *Courtesy Vernon Swaback.*

awards for its design, water conservation and quality of life. Lane, who retired upon leaving the project in 1993, credited the homeowner association and current executive director Jim Welch with excellent stewardship. "You can do everything right, but if you don't maintain it and keep things up, the newness fades and starts to look old." Genstar was eventually bought out by American Newland Corporation and never did another project in Arizona.

Reflecting back on his meticulous attention to detail, Lane said, "You want to do well, and the only way you're going to do well is to get into the details. You have to look at the big picture, but you also have to get into the critical details. When you go to Disneyland, it's clean, it's organized—attention to detail has been paid. So, when we started, I wanted it to be—not a Disneyland, but I wanted it to have the feeling that there's a *thought* behind everything. That it works and that it's clean. You have to have that aim."

Lane's high standards continue to resonate in Mountain Park Ranch some thirty-five years after initial groundbreaking. Due in large measure to one man's lofty aim, the master-planned community retains its unique livability and fresh feeling long after newer communities have begun to show their age.

It's Everyone's Business

Close-knit. Small-town feel. Everyone knows everyone. While these descriptions capture the character of the pre-village Ahwatukee Foothills, those alluring qualities endure despite the passage of time and the inevitable changes that have occurred. From a solitary Circle K store in 1976 to the future village's first gas station and card store three years later, Ahwatukee's early businesses mirrored the community's values and set a high standard for the ones that followed.

Mark Salem's Mobil gas station on the southeast corner of South 51st Street and Elliot Road opened in October 1979, followed one month later by Millie's Hallmark across the intersection. A few day-in-the-life vignettes reflect the Mayberry-like feel and small-town values of early Ahwatukee's business community, as it were. Working at the Hallmark store was typically a first job for many of its employees, and Millie Wynberg prided herself on teaching her staff—many of them young enough to be her grandchildren—the virtues of punctuality, honesty and courteousness. Life lessons were as much a part of the inventory as greeting cards and ceramic keepsakes. "If they didn't learn it here, they might not learn it at all" proclaimed the store's matriarch, who died in 2007.

Its proximity to the freeway and only-game-in-town status helped to make the new Mobil station an immediate success. Salem, who said that he "knew everyone" in burgeoning Ahwatukee, was aware that one of his elderly customers barely scraped by on her monthly Social Security check. Repairing the octogenarian's car meant doing a full brake job and complete

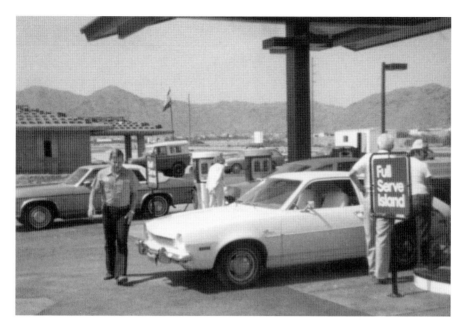

Mark Salem helps his first customer on October 2, 1979, opening day of Ahwatukee's first (Mobil) gas station. *Courtesy Mark Salem.*

tune-up—and then presenting the customer with a bill for seventeen dollars to fix "the noise" for which she'd brought the car in.

Business savvy sprinkled with a kindness borne of wisdom combined to set the tone during Ahwatukee's early years. But within the small community—"It was Hank and I; there was no one else," Salem said of those early days—the seeds of today's vibrant business community were sown. Salem, who has operated a twenty-bay auto repair shop in Tempe since 1994, and Hank Wynberg, who passed away one year after Millie, formed the first Merchants Association, joining forces to promote Ahwatukee businesses and the concept of shopping locally throughout the 1980s.

As the community grew so did the alliance, which by 1989 had evolved into the Ahwatukee Business Club. Comprising one commercial enterprise from each Ahwatukee industry (one plumber, one electrical contractor and so on), the club raised money for charitable causes as the community-minded collection of businesses supported and promoted one another. In 1994, realtor Chad Chadderton and financial services provider Tom Greninger organized the Ahwatukee Foothills Chamber of Commerce.

For future state senate majority leader and Kyrene justice of the peace John McComish, 1996 was a pivotal year. McComish's Little Professor

Bookstore had done well in its seven-year run a few doors down from Millie's, but with the coming of the Ahwatukee Foothills Towne Center on the southeast corner of 48th Street and Ray Road—prominently featuring a Barnes & Noble bookstore and signaling a transformation from the mom and pop simplicity of the '80s and early '90s to a larger, big-box setting— McComish saw the handwriting on the wall. The closing of his small independent bookstore coincided with the chamber of commerce seeking an executive director, and McComish, one of the chamber's founding members, easily made the transition.

At first operating out of a donated room in East Chandler Boulevard's urgent care building (currently under the Dignity Health banner), the chamber's 1998 move to a small Equestrian Center office at Equestrian Trial and the Warner-Elliot Loop was a bold one, according to McComish. "That was our leap," he said. "We went from zero rent, not even a phone and zero utilities to being able to pay our own way. Ahwatukee and the economy were growing, and life was good!" Five years later the chamber moved again, designing its own space in an industrial park adjacent the freeway north of Elliot Road. Today, the chamber offices are centrally located at East Chandler Boulevard and South 46th Street.

Under McComish's leadership the chamber grew from sixty-four member businesses in 1996 to its peak of almost six hundred by the time he stepped down to run for public office in 2006. The core concepts of networking, training and learning opportunities and community involvement were refined and expanded during this time. The chamber evolved into a respected resource for guidance on community-related issues, and it was during McComish's tenure that the organization began oversight of and enhancements to the village's annual Fourth of July fireworks extravaganza, known as the Red, White and Boom Community Fireworks Festival.

The national recession subsequently affected businesses large and small, taking its toll on chambers across the Valley. Today, the Ahwatukee Foothills Chamber of Commerce counts 475 member businesses. Sponsoring its annual Chamber Day of Champions, in which key players in the village's business community are recognized, is one way in which the chamber provides critical value to the community.

Through it all, one person stands alone as arguably the single biggest influence in the growth and development of Ahwatukee Foothills' business community. Clay Schad, founder and editor of the *Ahwatukee News*, now the *Ahwatukee Foothills News,* used his unique position to tirelessly promote and champion Ahwatukee Foothills businesses via the printed word. The

An early Ahwatukee Plaza business, the Arizona Bank, opened in January 1980. Presley's Lew Wilmot (*left*), Bruce Gillam (*third from left*), Phil Martin (*to Gillam's left*) and Pete Meier (*fourth from right*) attended the groundbreaking. *Courtesy* Ahwatukee Foothills News.

newspaper enthusiastically profiled both new and existing businesses and prominently spotlighted their advertisements week after week, encouraging readers to get to know their local merchants as friends and neighbors. Said Ahwatukee security founder Mike Collins of Schad, "He did stuff for free in the newspaper for many, many people to help them get their business started. Clay probably printed as much ink for free as he did for pay."

Schad, who sold the periodical in 1998, was a relentless booster of the chamber of commerce during its early years, helping to foster the concept of Ahwatukee Foothills as a tightly knit small town in which business was a welcome and integral fabric within the community.

It is left to Mark Salem to sum up the spirit that gave and continues to give Ahwatukee its uniqueness. Reflecting on a night in the 1980s when monsoon rains flooded several intersections, Salem recalled the heroic efforts made by his staff in rescuing stranded Ahwatukeeans from stalled cars and towing their vehicles out of harm's way. Reconvening at his gas station after midnight, he and his staff members quietly sipped a well-earned victory drink. Salem knew that Ahwatukee residents were home, safe and sound, because all of the streets had been cleared. "All of the cars

had been towed, and all of the vehicles winched out of the ditches. We'd gotten everyone home safely and were pretty proud of that."

Community pride. Neighbors helping neighbors. Value for the money. Those descriptions are as applicable to today's village businesses as they were in the pre-village days when unobstructed views of Camelback Mountain prevailed. Like the village that it serves, Ahwatukee Foothills' business community began as a quaint patchwork of entrepreneurial pioneers banding together to create a vibrant network of go-to resources. In tandem with the chamber of commerce, today's businesses are the guardians of the proud legacy and high standards bequeathed to them by those early pioneers.

GHOSTS OF AHWATUKEE PAST

*I*t was inspired thinking, if only partially motivated by the spirit of the season. The idea of stringing white lights down the center of Chandler Boulevard to help showcase the as-yet-undeveloped Foothills saw its genesis as the brainchild of Del Webb marketing director Ann Glover back in 1986, shortly after The Foothills' grand opening. Modest by today's standards, Glover's illumination of a portion of Clubhouse Drive for about a hundred yards created interest and sparked a seasonal tradition. It foretold the annual yuletide event to follow.

With the first homeowner moving in that summer, 1988 saw the beginning of what was called the Saguaro Festival of Lights. Quaintly, a local publication observed that "the winter wonderland with a southwestern style attracted thousands of visitors who drove on paved roadways through mountainous terrain to view the presentation." An accompanying Arts & Crafts Festival held at The Foothills Information Center, now the Foothills Golf Club clubhouse, was the forerunner of today's Festival of Lights kickoff party in the park. The annual event now draws upward of twelve thousand people each Thanksgiving weekend.

Mark Salem managed Ahwatukee Foothills' first service station and knew Phoenix traffic reporter and area celebrity Jerry Foster from Salem's days as a member of the Scottsdale police force. Mark and Hank Wynberg, he of the future village's first greeting card store, decided that Foster ferrying Santa Claus into Ahwatukee Plaza's parking lot would be good for business in the half-filled shopping plaza. So in 1981 Salem arranged for Foster to helicopter

Santa alternatively from Coca-Cola's wide-open parking lot or Sanders Aviation, both just across the freeway, into Ahwatukee Plaza's lot.

There, in a grand entrance, Santa was greeted by Mrs. Claus and a throng of cheering families in what would go on to become an annual day-after-Thanksgiving ritual. Accompanying Foster, red-suited and behind the white beard, was Mountain View Lutheran Church's pastor, Reverend Don Schneider, who was met on the ground by an appropriately red-suited Millie Wynberg, proprietor and namesake of Millie's Hallmark. Both of these Ahwatukee standard bearers served in their pre-Christmas roles into the mid-1990s as the inaugural event grew into an annual tradition. Foster, one of the first TV helicopter pilots in the Valley, enjoyed posing for photos with the assorted throngs, considering the gig his most rewarding assignment.

During the early decades of the twentieth century when the Ahwatukee Ranch stood majestically on the land that comprises a major part of today's village, Christmas tradition could be found in both the sprawling ranch house and the modest home of its caretaker, Byron Slawson, and his family. Following her husband's death in early 1922, the widow Ames took a special liking to Byron and Matilda Slawson's five children, all

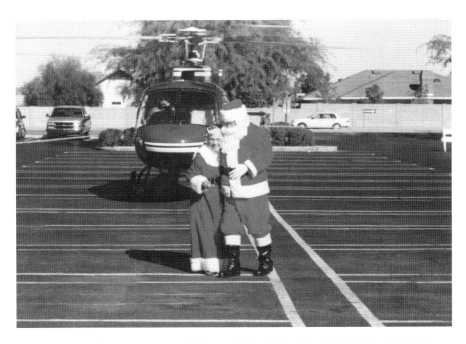

Ahwatukee icons Millie Wynberg and Reverend Don Schneider delighted hundreds of children each year as Mr. and Mrs. Santa Claus. *Courtesy Linda and Tom Olson.*

born during the 1920s. Herself childless, Virginia Ames's grandmotherly persona manifested itself in the annual open-house Christmas parties that she threw for the Slawson kids and their friends at the Kyrene School. Then, ferried by school bus to the Ahwatukee Ranch (known as "The Castle" to many of the students), the Depression-era children enjoyed hot chocolate, brightly wrapped Christmas gifts and the warmth of the season that Mrs. Ames delighted in sharing.

The Slawson children—Anne, Robert, Delilah, Wanda and Burma— enjoyed a special camaraderie with Mrs. Ames. Ushered into the twelve-thousand-square-foot ranch house for their own private seasonal celebration, each child received a sack containing an orange and some candy, gazed in awe at the house's magnificent interior and took particular delight in sitting at the long dining room table that could accommodate more than twenty people. Observing Santa Claus emerge from a door in the two-thousand-gallon water storage facility that towered over the house, youngest daughter Burma believed for years that Santa resided high up in the tower.

The Slawson children (Robert, Delilah, Wanda, Anna Marie and Burma) all shared a special camaraderie with Mrs. Ames. *Courtesy Burma Slawson Evans family collection.*

Merry Christmas

Helen Brinton's southeastern view of the Ahwatukee Ranch house rang in the season in the 1950s. *Courtesy Burma Slawson Evans family collection.*

In sharp contrast to their warm memories of Christmas with Mrs. Ames, the Slawson children found second owner Helen Brinton to be of a children-should-be-seen-and-not-heard persuasion, following her purchase of the property two years after Mrs. Ames's 1933 death at age seventy-seven. We do have Brinton to thank for the accompanying Christmas card, and she did employ the older Slawson girls as servers on a few occasions when hosting midwestern winter visitors. The girls were required to wear maid uniforms and instructed to remain in the sprawling ranch house's kitchen until summoned by a buzzer, which Brinton could activate with a button underneath the massive dining room table. That worked well enough until Delilah forgot what that annoying buzzing was for, thereby ending her career as an Ahwatukee Ranch server.

Just 150 yards southeast of the main house, Byron and Matilda Slawson enjoyed their own Christmas traditions. Although well under one thousand square feet, the Slawson home consisted of five rooms including two bedrooms,

plus a covered porch at the rear of the house that served as a third sleeping area. Adjacent to their eight-by-eight-foot kitchen Matilda decorated the family tree with gumdrops, as was customary during the 1930s. During the Great Depression each Slawson child was given one dollar to buy a gift for every member of the family. Later, with the arrival of grandchildren, Byron's small aluminum tree held an envelope containing a few two-dollar bills for each child, an eagerly awaited gift among the grandchildren.

Byron Slawson remained on the ranch under the terms of the life-estate in Helen Brinton's will upon her death in 1960, which allowed him to live on forty acres of the property for the remainder of his life as long as he paid the taxes. Slawson was urged to contest the will to keep the acreage in the family, but the humble caretaker chose not to. Consistent with his lifelong gratitude for the blessings bestowed on him, Slawson remained grateful for what he had.

Referring to her childhood, the late Delilah recalled those late 1920s and early Depression years as ones in which "we didn't know we were poor." And indeed, while her reference is to material possessions, the Slawsons would seem to have had an abundance when measured by friends, social activities—their house was a gathering place for a multitude of schoolmates and friends in the Kyrene farming community—and family relationships. It's an appropriate sentiment on which to reflect at any time of the year.

Exit Strategy

Abraham Lincoln signed the Homestead Act into law in 1862, opening the untamed West to settlement. It took the signature of another U.S. president, Dwight Eisenhower, on the Federal-Aid Highway Act ninety-four years later to establish the national highway system, a portion of which would come to so prominently define Ahwatukee Foothills' eastern border. A national Highway Trust Fund of $25 billion was established in 1956 for construction of forty-one thousand miles of interstate highways. Under the law's sweetheart provisions, 90 percent of interstate highway construction costs were borne by the federal government, with individual states responsible for a mere 10 percent of the total.

Like most highways Interstate 10, which stretches from Santa Monica, California, to Jacksonville, Florida, was built in sections over several years. The last section to be completed between Phoenix and Tucson (officially known as the Maricopa Freeway) was the connection between Phoenix's South 40th Street and Baseline Road, fostering a connection with a previously constructed section of future freeway adjacent to the land that would one day become the Village of Ahwatukee Foothills.

Reflective of the non-destination that was the pre-freeway Kyrene farming community, the portion of the interstate between Baseline and Williams Field (now Chandler Boulevard) roads was constructed in 1965–66 but left unconnected, unmarked and unused until the South 40th Street–Baseline Road section (now affectionately known as the Broadway Curve) was opened in 1968. Thus, for almost two years, the five-mile stretch between

Mid-1960s construction of Interstate 10 would bisect the land, as seen in this May 1961 aerial photo of Elliot, Warner and Ray Roads (*top to bottom*). *Courtesy Landiscore Inc.*

Baseline and Williams Field roads remained pristinely unutilized. A few area farmers cut its protective cables in order to drive their tractors across the "who built this here?" pavement, and an occasional drag-race on the virgin straightaway proved to be irresistible to a few of Tempe's local yokels. Otherwise, the stretch of pristine pavement remained undisturbed until its dedication by Governor Jack Williams on September 18, 1968.

The flat-as-a-pancake Elliot and Warner dirt roads in the freeway's path were elevated to allow the interstate to pass underneath, using fill excavated from a pit that was dug next to the future freeway between Ray and Warner Roads. Excavation to elevate Ray and Williams Field Roads was transported from the site of today's Cotton Center, a few miles north in Phoenix. A. Wayne Smith, designer of Ahwatukee's first master plan, who would eventually establish the Farm at South Mountain, approached the Arizona Department of Transportation about buying the hole in the ground east of the freeway between Warner and Ray in the mid-1970s. The landscape architect in Smith envisioned a park-like "Hanging Gardens"

in the gaping pit, with terraced roads leading to lushly landscaped small office buildings, restaurants and, finally, a scenic lake at the bottom.

In a what-might-have-been scenario similar to that of San Marcos in the Desert—Dr. Alexander Chandler's three-hundred-room resort/hotel near today's western Mountain Park Ranch whose plans were abandoned in 1929—Smith was rebuffed by the Flood Control District of Maricopa County, which elected to keep the man-made crater as a two-hundred-year-flood-control retention basin. Thus, the cavernous hole in the ground adjacent to Interstate 10's northbound lanes between Ray and Warner Roads remains gaping and undeveloped, a legacy of freeway construction a half century ago. In mid-2018, the City of Tempe proposed turning part of the pit into a park.

Four roads crossed Interstate 10 adjacent Ahwatukee Foothills, but only Williams Field Road (now East Chandler Boulevard) had freeway access ramps in 1968. Evoking the easy-money spirit of the Federal-Aid Highway Act, single-lane freeway ramps were constructed at Elliot Road in the fall of 1971. Plans for the ramps were implemented even before approval of Presley Development of Arizona's master plan for development of Phase I of its "Tempe Property" was granted. At the time, Elliot Road was little more than a dirt farm road, paved only on the narrow portion covering the overpass. Nevertheless, it joined Williams Field Road three miles south as one of two freeway access points, although it would be another fifteen years before the community's growth merited freeway ramps at Warner and Ray Roads.

Once open for business the Maricopa Freeway changed the face of the landscape. Tempe Rural Delivery mailing addresses faded away on the west side of Interstate 10. The freeway created a tangible barrier to Tempe's westward encroachment and transformed an area with one isolated winter residence (the Ahwatukee Ranch), a few scattered farms and a proving grounds into one that could be easily accessed by the masses. When developer Randall Presley purchased the no-man's-land in 1970, the freeway's proximity to the future Ahwatukee was one of its main selling points.

Years later, a much harder sell was a parkway to be built near one of Ahwatukee's boundaries. On the drawing board for decades, the roadway fueled hotly contested public debates, pitting City of Phoenix planners against emotionally charged Ahwatukee citizens. While the thoroughfare may have been a good idea when first proposed, the master-planned community's dynamic growth had transformed formerly barren desert into bustling neighborhoods precariously close to the proposed route.

Maricopa Freeway rush hour traffic approaching the Elliot Road overpass was a bit lighter in 1969, as an unobstructed Camelback Mountain beckons in the distance. *Courtesy Arizona Department of Transportation.*

Today's South Mountain Freeway Loop 202, on Ahwatukee Foothills' southern boundary, for which a half-cent sales tax was approved in 1985? Hardly. It was the Scenic Drive near Ahwatukee Foothills' northern border—first proposed in the National Parks Service's master plan of 1935. The aptly named parkway, originating at Guadalupe Road and exiting South Mountain Park preserve around 35th Avenue, was to have followed the contour of South Mountain at its base, allowing Sunday driving motorists a beautiful view of South Mountain Park and beyond, for as far as the eye could see.

Unfortunately, by the time construction was actually contemplated in the mid-1980s, the view "beyond" was largely limited to tiled rooftops. Former City of Phoenix planning director Rick Counts recalled that the roadway was originally envisioned as providing easy access to the "charm" of South Mountain both for future residents and for research and development businesses that would find that type of setting desirable. In addition, it was seen as a practical way to create a buffer between eventual development and

South Mountain Park. The planned roadway languished on the drawing board for fifty years, which didn't stop Phoenix Parks and Recreation representatives from making one final push in the summer of 1986.

With city road graders at the ready, concerned Ahwatukee residents formed Citizens for an Environmentally Sound Park Development (CESPD). The grass-roots organization quickly made its presence felt, raising objections over noise and air pollution, increased fire danger, vandalism and destruction of the natural environment (particularly at the southwestern portion of the mountain preserve). In response to this last concern, one city councilman floated the idea of routing that portion of the thoroughfare south onto the adjacent Gila River Indian Community.

As a result of CESPD's push the city commissioned an independent study to research the best use of the park preserve. Increasingly vocal protests focused on the extent to which development had altered the landscape since the roadway was first proposed. That, combined with city hall's waning appetite for taking on the project, resulted in Mayor Terry Goddard pulling the Scenic Drive plug in 1988. More recently, similar dynamics along the village's southern border made for déjà vu as the South Mountain Freeway Loop 202 was built.

From the peaceful isolation that the early homesteaders enjoyed a century ago to today's daily crawl during morning and evening rush hour, the community itself owes its very existence to a postwar undertaking that would serve as a major catalyst for the development of Ahwatukee-Foothills: the Maricopa Freeway, better known as Interstate 10.

THE MYSTERY OF THE LOST RANCH

*I*t's an Ahwatukee Foothills mystery that, alas, may forever be lost to history. Tucked up against the foot of South Mountain near what used to be the end of East Chandler Boulevard, lie the remains of a structure that cries out for explanation and historical context. Or rather, it is we who cry out in search of answers.

Phoenix's South Mountain Park rangers refer to the mystery structure—a tiered concrete foundation with two stone fireplaces nestled on a plateau backing up to the mountain and facing south toward the Gila River Indian Community—as the Lost Ranch. Easily accessed via a City of Phoenix trailhead and natural wash not far from 17th Avenue, the ruins sit roughly one mile or so northwest of the nearest neighborhood. Scores of curious hikers routinely pass by, unaware of just what it is that sits before them.

What *was* the multi-room structure in its heyday—and when may that have been? Could the building have been a private residence? A miners' camp? Perhaps a government work project? No one, including the rangers, seems to know for sure. Public records document South Mountain's major early twentieth-century mining camps, with the ruins of the Max Delta gold mine among the most prominent, on the north side of the mountain.

But while smaller, scattered mines operated on the mountain's south side and at least a few are in proximity, there was no counterpart for the Max Delta. Seemingly no records exist that might explain the circumstances, background or intent of the Lost Ranch and whoever built it. What is certain

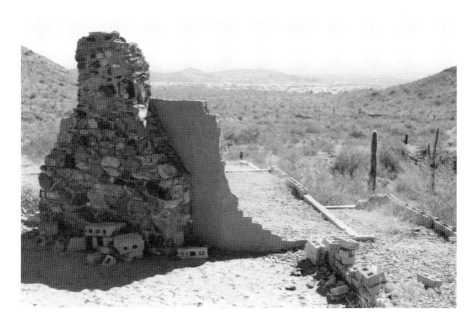

At the foot of South Mountain the Lost Ranch stands guard over all that it surveys, miles southeast to the Gila River Indian Community. *Submitted photo.*

is that a long time ago, someone went to a lot of trouble to build a structure that has partially survived well beyond its original intended purpose. An air of mystery prevails.

In an attempt to unravel the mystery, three local gents who spent most of their lives in and around the Kyrene farming community and later Ahwatukee Foothills were consulted in 2008. Lifelong residents of and hikers in the area with a rare familiarity with it, Tom Carney was ninety-one, Tom Owens eighty-nine and his cousin Jack Owens eighty-six at the time. All three men are now deceased. Having grown up on family farms near the Kyrene School, each had a rare familiarity with the area's people and events, as well as the lay of the land, from the 1930s on. All three possessed powers of recall belying their years.

If Tom Owens knew the secret of the ruins he never let on. Owens recalled dancing with groups of friends to the accompaniment of a portable radio on the structure's concrete slab as a young man in the late 1930s and 1940s. Some seventy years later, Owens said that the structure had no walls back then and didn't look a whole lot different than it does now. Although Tom Carney was a friend of Owens's, it was only in 2008 that he viewed the structure for the first time. His rough measurement

resulted in a guesstimate as to the size of the mystery building, putting it at perhaps two thousand square feet.

With little more than that to go on it fell to Jack Owens to provide a few tantalizing shreds of information about the place, as handed down to him by his father when Jack was in his teens. Mac Owens, who built the Pima Ranch outbuildings, was born in 1900 and lived in Phoenix before moving to the Kyrene area in the 1920s. According to Mac, after World War I he and his friends would ride their Indian motorcycles south from Phoenix along 51st Avenue toward the St. John's Mission on the Gila Indian Community, southwest of today's Ahwatukee Foothills. Having passed South Mountain's west side, the group would turn back around the south side of the mountain and head east, navigating primitive dirt trails several miles into the foothills.

For the majority of the twentieth century, East Chandler Boulevard extended west only as far as 32nd Street. Unlike today, the Lost Ranch could be accessed only from the west in Mac's day—and even then only via horse or motorcycle. No roads existed within miles of the structure, and this may have played a role in its site selection. Mac described horse-and-buggy transportation over rough desert to and from the building, with whatever was there giving it a reputation as a "wild place." Frustratingly, no further elaboration was provided. Jack was never given a description of the physical premises or who might have built or owned it, and he had no idea of the circumstances that led to its apparent deconstruction and the condition in which we find it today. His father, Mac, died in 1969.

Ten years after Carney and the Owenses shared what little they knew about the ruins, Arthur Hunter's grandson, Joe Garner, recalled what he'd been told over the years. Garner, sixty-nine at the time of this writing, said that two of Hunter's more rambunctious sons, Arthur Jr. and Leslie (nicknamed "Tinker" and "Tiny" and born in 1918 and 1919, respectively), cryptically filled him in on their own recollections of the place. Built in the late 1920s, Garner's now-deceased uncles said that building materials, supplies and liquid refreshment were brought to the site by mule. It had a bar, for sure. An Old West saloon environment characterized at least one of the rooms, with a party atmosphere permeating the joint, perhaps reflective of access to alcoholic beverages at a time when it was illegal to sell, manufacture or transport them. How, why and when the structure's walls and roof came down the brothers never said. But local authorities taking sledgehammers to places deemed to be in violation of the law was an occasional practice during the Prohibition era.

And so we are left with a theory, an educated guess about the ruins that taunt us and leave us with more questions than answers. Who built it? What became of the roof and walls? What exactly was its purpose? While Jack Owens didn't know, he believed that the structure very well could have been a Prohibition-era (1920–33) speakeasy. Tom Owens was certain that at least one existed in the foothills of South Mountain and said that the Lost Ranch might very well have been it. Tom Carney, wryly observing that "there was no building permit for that thing," didn't disagree. Joe Garner's take: Who's to say that the Lost Ranch wasn't a speakeasy?

Predating South Mountain Park (or maybe not), established in 1924, the "wild place" of young Mac Owens lives on. Unfortunately, with each passing year, the likelihood of ever discovering the true history of the Lost Ranch becomes more remote. While most of the old-timers are no longer with us, perhaps someone who still is can provide an explanation where solid conclusions have thus far been elusive. If only fireplaces could talk.

Some Very Good Years

S tatehood day celebrated Arizona's centennial in 2012. This look back takes a decidedly local turn in a review of milestones that helped to shape Ahwatukee Foothills. Exhausting but by no means exhaustive, this compilation concludes with the naming of the village in 1991.

1862–1920

1862: President Abraham Lincoln signs the Homestead Act, opening up the untamed West to settlement.

1888: Kyrene School District and its namesake school are established at the corner of the eventual Warner and McClintock Roads. Colonel James McClintock teaches seventeen children in the one-room schoolhouse; no signs of life west of the district's 56th Street boundary.

1908: Samuel Warner arrives from Kansas and homesteads 160 acres near today's southeast corner of Priest Drive and the road that bears his surname.

1909: Homesteader Arthur Hunter lays claim to 160 acres near today's South 48th Street and Thistle Landing.

1911: Hunter builds a farmhouse on Hunter Drive, a dirt lane that would eventually become South 48th Street. Hunter Drive would remain so named until the early 1970s.

1911: Dedication of Roosevelt Dam, seventy-six miles northwest of Phoenix initiates a controlled water delivery system to homesteading farmers via a series of irrigation canals.

1913: Dr. Alexander Chandler's San Marcos Hotel opens with the first golf course in the state. Among its eventual winter visitors are midwesterners William Ames and Helen Brinton, builder and second owner, respectively, of the Ahwatukee Ranch.

1914: Californian Reginald Elliott homesteads 160 acres near today's southeast corner of Priest Drive and, well, you know.

1916: Studebaker manufactures sedan purportedly owned by Al Capone and eventually purchased by Arthur Hunter. The bullet-riddled vehicle was disassembled and buried in the Ahwatukee desert by Hunter in the 1940s.

1917: Texan Bill Collier, founder of Lakewood predecessor the Collier-Evans Ranch, takes job washing windows at Chandler's San Marcos Resort.

1920: Kyrene School is moved to the northwest corner of Warner and Kyrene Roads due to a high water table at the original school grounds. The few homesteaders' children in the Kyrene farming community east of 56th Street attend.

1920: William Ames acquires eight sections of land adjacent South Mountain—each section equals one square mile—for four dollars per acre and begins constructing a grand winter residence at the end of Warner Road.

1920: Prohibition begins. The ruins of the Lost Ranch, rumored to have been a speakeasy, remain today in the foothills near Chandler Boulevard and 17th Avenue.

1920s–1940

1920s: Dr. Chandler's Land Improvement Company acquires thousands of acres in today's western Ahwatukee Foothills.

1921: William and Virginia Ames move into their seventeen-room, twelve-thousand-square-foot Case de Sueños (House of Dreams) on Thanksgiving Day. William dies three months later, and Virginia continues to winter there until her death in 1933.

1922: Byron Slawson becomes caretaker of Casa de Sueños, residing on the property with his family until his death in 1976.

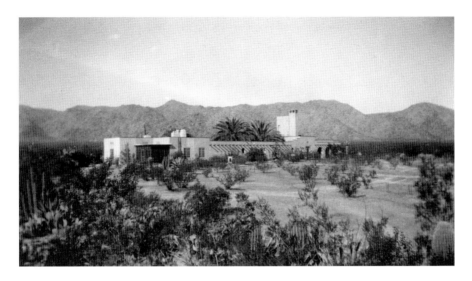

The Ahwatukee Ranch house in 1942. *Courtesy Burma Slawson Evans family collection.*

1924: The City of Phoenix purchases thirteen thousand acres from the federal government for a total of $17,000 and establishes South Mountain Park. The largest U.S. municipal park eventually grows to close to seventeen thousand acres, including a portion of donated Ames land.

1926: Kyrene School gets its first school bus, furnished with a wooden bench and driven by a moonlighting schoolteacher.

1929: Frank Lloyd Wright is hired by Chandler to design the three-hundred-room San Marcos in the Desert resort on six hundred acres near the western border of what would become Mountain Park Ranch. Wright establishes a base camp north of today's Desert Vista High School, but October stock market crash kills investment in the resort, which is never built.

1929: New Yorker William Belden acquires three hundred acres near the future Ray Road and Sun Ray Park, with plans for a winter residence to rival Casa de Sueños. Belden dies the following year, as do plans for his house. Belden's widow and son spend winters in three small Pima Ranch outbuildings constructed prior to Belden's death, the only residents of the future Mountain Park Ranch for the next four decades.

1933: Virginia Ames dies, having previously donated part of her land to Phoenix's South Mountain Park.

1935: San Marcos winter visitor Helen Brinton acquires Casa de Sueños. A botched translation into the Crow Indian language results in the

166

house being renamed "Ahwatukee," a word that does not exist in the Native American language. Other theories regarding the origin of the community's name persist.

1930s: Phoenix's Lightning Transfer and Storage Company acquires eight hundred acres east of the Ahwatukee ranch, which would become Ahwatukee's core in the early 1970s.

Late 1930s: For forty dollars per acre, Bill Collier acquires, clears and begins farming the square-mile of land that would become the Collier-Evans Ranch. Operations continue into the mid-1980s, when the land is developed as Lakewood.

Late 1930s: With a plethora of Arizona roads sharing its name, Pima Road is renamed Ray Road in tribute to an early east Valley farming family.

1940: Kyrene farming community's Tom Owens, Samuel Warner's grandson, marries Hazel Elliott, Reginald Elliott's daughter. The result is the original Warner-Elliot Loop.

1940s–1969

1943: During World War II, Californian Randall Presley receives pilot training at Glendale's Thunderbird Field. He sees Phoenix for the first time—but not the last.

1946: International Harvester Company leases 1,920 acres on a World War II U.S. army tank testing facility west of the Collier-Evans Ranch for use as a truck and heavy equipment proving grounds. A few years later, the operation expands to more than four thousand acres on the site of the future Foothills and Club West.

Late 1940s: Rowd Sanders begins crop dusting the Kyrene farming community from his airfield on two hundred acres near today's Elliot Road Walmart. Sanders plants hundreds of citrus trees, and Tempe's Grove Parkway is carved through the property in 1985.

1949: Richard Evans marries one of Bill Collier's daughters and joins his father-in-law farming the Collier-Evans Ranch.

Early 1950s: West Chandler Road is renamed Williams Field Road and paved for the primary benefit of Mesa's Williams Airforce Base. Until the development of Mountain Park Ranch in the mid-1980s, the road ends at South 32nd Street, just east of International Harvester's Proving Grounds.

1950s: Tempe resident Marian Vance sharecrops on Lightning Transfer's eight hundred acres east of the Ahwatukee Ranch, where the Ahwatukee Country Club golf course will be built in the early 1970s. In deference to its owner, the agricultural fields become known as the Lightning Ranch.

1960: Helen Brinton dies. The Ahwatukee Ranch and surrounding property changes hands and is eventually purchased by a land syndicate headed by ASU English professor and land investor John Ratliff.

1965–66: Construction begins on an extension of the Maricopa Freeway (Interstate 10) from Phoenix to Casa Grande, bisecting the remaining Kyrene farming community and future Ahwatukee Foothills from Tempe and Chandler.

1967: Superstition Freeway construction begins with the Goldman Dairy in its path. Milt Goldman relocates his eight-hundred-cow operation onto land west of the Collier-Evans Ranch and west of today's Desert Vista High School.

1968: Interstate 10 between Phoenix and Tucson opens. The only local access ramps are at Williams Field Road, with empty desert in the view to the west.

1968: International Harvester Company buys the future Foothills' 4,140 acres for $1.6 million at a City of Phoenix auction.

1969: The Goldmans build their house on the hill, which today overlooks the two Kyrene schools (Akimal and Estrella), built on the southern portion of their relocated dairy.

1969: Californian Randall Presley (see 1943) forms Presley Development Company of Arizona and begins development of an eighty- and a one-hundred-acre parcel in the west Valley.

1970–1980

1970: Randall Presley acquires 2,080 acres south of South Mountain and west of the freeway. The area is considered remote and is isolated by Interstate 10 and South Mountain.

1971: Cities of Tempe and Chandler reject Presley's overture for annexation. In anticipation of future development, freeway access ramps are constructed at Elliot Road.

1971: Land planner A. Wayne Smith creates the initial master plan for the Tempe Property, the future Ahwatukee. The proposed development

would be the first master-planned community south of South Mountain, with Phase I approved by Maricopa County in November.

1972: Water arrives in the future Ahwatukee, pumped north from three wells near the intersection of Interstate 10 and today's Loop 202. Hunter Drive is renamed South 48th Street.

1972: Initial development of the future Ahwatukee Foothills begins with construction of the Ahwatukee Country Club Golf Course and Ahwatukee Recreation Center.

1972: Helena Belden (see 1929) dies. Utah alfalfa farmer and land investor LeRoy Smith acquires Pima Ranch's 2,670 acres from her estate, land that would become Mountain Park Ranch.

1973: Presley opens seventeen model homes on Mesquitewood Drive. Ahwatukee's grand opening is in April.

1973: $5 million set aside by the Arizona legislature for construction of a prison on 320 acres of state land just west of the proving grounds. Seemed like a good idea at the time.

1973: In September, Mac and Ellie Roach become Ahwatukee's first residents, on Magic Stone Drive.

Presley Development's sales office wall in 1973, depicting the new development's first houses for sale. *Courtesy Robert Peshall.*

The entrance to the seventeen model homes, on what became Mesquitewood Drive at South 51st Street. *Courtesy Robert Peshall.*

1974: Ahwatukee Recreation Center opens in February with singer Tennessee Ernie Ford as pitchman, helping to fuel the perception of Ahwatukee as primarily a retirement community.

1975: The Ahwatukee Ranch house, having stood for fifty-four years but now in severe disrepair and deemed to be too far from the freeway, is demolished.

1976: The *Ahwatukee Sentinel* debuts as predecessor of the *Ahwatukee News*.

1976: Circle K opens on Elliot Road as Ahwatukee's first retail establishment. It would remain the only food store in Ahwatukee until 1980.

1976: Byron Slawson, caretaker of the Ahwatukee Ranch, dies after living on the ranch property for fifty-four years.

1976: Kyrene de las Lomas, Ahwatukee's first school, opens in December on the Warner-Elliot Loop at Equestrian Trail.

1977: Ahwatukee's first Easter Parade is held on April 9. The only float in the twenty-entry parade carries two Presley Development Company secretaries.

1977: Mountain View Lutheran Church opens on South 48th Street as Ahwatukee's first house of worship, serving as a meeting place for several denominations until construction of their own facilities occurs over the next few decades.

1977: LeRoy Smith hires A. Wayne Smith to help market his Pima Ranch property. This results in the initial design of the eventual Mountain Park Ranch.

1978: In July, Nebraskan Clay Schad begins publishing the *Ahwatukee News* as a four-page monthly newspaper. The initial press run of two thousand is largely distributed to businesses on the Tempe side of the freeway.

1979: The Slawson house, completed during construction of Casa de Sueños in 1921 and where Byron and Matilda raised their five children, is demolished.

1979: Ahwatukee's first gas station opens in October and is followed one month later by its first shopping plaza tenant, Millie's Hallmark Card Shop.

1980–1991

1980: Elliot Road's Ahwatukee Plaza opens on the southwest corner of 51st Street and Elliot Road. Alpha Beta becomes the future village's first grocery store in its first shopping plaza. Circle K's run as a main source of sustenance ends.

1980: The House of the Future on Equestrian Trail opens in March. By the time its last tour bus idles four years later, 250,000 people have toured the futuristic house, with millions more viewing it through major media coverage in thirty-three countries.

The House of the Future in 1980. *Courtesy Pete Meier.*

1980: Charles Keating's Continental Homes acquires the future Mountain Park Ranch from LeRoy Smith. The City of Phoenix agrees to annex, and Continental begins initial offsite infrastructure development the following year.

1981: An "Annexation Implications" report by the City of Phoenix projects eighty-six thousand people as eventual residents of the future Ahwatukee Foothills. Based on 1980 census data, the combined population of the future Mountain Park Ranch and Lakewood is nineteen, with eleven more in the Foothills and Club West-to-be. Included in the report is a recommendation for a six-lane controlled-access road along Pecos Road, connecting the area with Phoenix's 51st Street.

1981: International Harvester builds a $2.5 million sales center on its proving grounds. The building subsequently becomes The Foothills Information Center and the Foothills Golf Club clubhouse.

1982: Harvester pledges its 6.5-square-mile property as collateral against a $28 million patent-infringement award to John Deere & Company.

1982: The City of Phoenix annexes 16.5 square miles of the future Ahwatukee Foothills, including portions of what would become Lakewood and The Foothills.

1983: Ahwatukee and Mountain Park Ranch land planner A. Wayne Smith buys five distressed acres in South Phoenix and transforms them into The Farm at South Mountain, adding to the acreage over the years.

1984: In January, Arizona developer Robert Burns of Burns International acquires Harvester's 4,140 acres for approximately $20 million. At the time, it is the largest single real estate transaction between one buyer and one seller in Phoenix history.

1984: The official March groundbreaking on Mountain Park Ranch is held; at the time it is the largest proposed master-planned community in the city of Phoenix.

1984: Keating's Continental Homes, having sold its interest in Mountain Park Ranch to Canadian developer and joint-venture partner Genstar, buys the square-mile Collier-Evans Ranch for development as Lakewood.

1985: In April, first homeowners move into Mountain Park Ranch.

1985: Voters approve a half-cent sales tax to fund a freeway along Ahwatukee's southern border. Plans are for construction to commence within a few years.

1986: Interstate 10 access ramps open at Warner and Ray Roads.

1986: Del Webb joint-ventures with Burns International and The Foothills groundbreaking occurs in May. In December, Webb marketing director

Ann Glover strings lights on Clubhouse Drive, the first display in what would evolve into today's annual Festival of Lights.

1987: Estes Homes buys part of the Goldman Dairy land for $47,000 per acre. The dairy once again relocates, this time to Coolidge.

1987: In April, Burns makes its first land-parcel sale, to the Arizona Department of Transportation. The five-hundred-foot-wide, multi-mile-long strips of land at the southernmost part of its project just north of Pecos Road are designated as a clean-take area for a future freeway.

1987: The annexation process is completed. "Ahwatukee" mailing address is relegated to history.

1988: The first homeowners move into The Foothills in July.

1988: UDC Homes buys the 1,100-acre Phase III of The Foothills, giving rise to the future Club West.

1991: Mountain Pointe High School opens on Knox Road as Ahwatukee's first. It is joined five years later by Desert Vista High School on South 32nd Street.

1991: The City of Phoenix designates 35.8 square miles as the Village of Ahwatukee Foothills.

SELECTED BIBLIOGRAPHY

Blank-Roper, Laurie, and Richard W. Effland. *Archaeological Investigations at Two Sites within the Ahwatukee Expansion Area.* Archaeological Consulting Services Ltd., January 1981.

Collins, William S. *The Emerging Metropolis: Phoenix, 1944–1973.* Arizona State Parks Board, 2005.

DuPree, David M. "Vanished Flying Fields." Independent, Arizona, 1998.

Effland, Richard W., and Margerie Green. *The Mystic House: Documentation of the Ahwatukee Ranch and the Slawson Home.* Archaeological Consulting Services Ltd., July 1981.

Furlong, Ben. *The Story of Kyrene.* Kyrene School District, 1992.

Gammage, Grady, Jr. *Phoenix in Perspective.* Arizona Board of Regents, for and on behalf of Arizona State University, and its College of Architecture and Environmental Design, Herberger Center for Design Excellence, 1999.

Green, Margerie. *Archaeological Test Investigations at Pima Ranch.* Archaeological Consulting Services Ltd., May 1983.

———. *A National Register Evaluation of Camp Ocotillo and Pima Ranch.* Archaeological Consulting Services Ltd., January 1983.

———. *Proposed Ahwatukee Expansion.* Archaeological Consulting Services Ltd., November 1979.

Green, Margerie, and Richard W. Effland. *Archaeological Investigations at the Pecos Ranch Development Property.* Archaeological Consulting Services Ltd., May 1984.

About the Author

*M*arty Gibson grew up on Long Island, New York, and is a graduate of the New York Institute of Technology. A stained-glass artist and accomplished photographer, he has won numerous competitive public speaking contests and awards. His hiking pursuits have taken him to Death Valley, Seattle's Mount Rainier, California's Channel Islands and, annually, to Grand Canyon. Gibson's passion for local history was sparked by the absence of historical repositories, of which this book is now one. A thirty-two-year Arizona resident, Gibson makes his home in the former Kyrene farming community.